The iPad
FOR PHOTOGRAPHERS

Master the Newest Tool in Your Camera Bag

JEFF CARLSON

PEACHPIT PRESS

The iPad for Photographers:
Master the Newest Tool in Your Camera Bag
Jeff Carlson

Peachpit Press
1249 Eighth Street
Berkeley, CA 94710
510/524-2178
510/524-2221 (fax)

Find us on the Web at: www.peachpit.com
To report errors, please send a note to errata@peachpit.com
Peachpit Press is a division of Pearson Education.

Project Editor: Susan Rimerman
Production Editor: Tracey Croom
Copyeditor/Proofreader: Scout Festa
Indexer: Karin Arrigoni
Composition: Jeff Carlson
Cover Design/Photo Collage: Mimi Heft
Interior Design: Mimi Heft

ISBN 13: 978-0-321-82018-1
ISBN 10: 0-321-82018-5

9 8 7 6 5 4 3 2 1
Printed and bound in the United States of America

For Steve. Thank you.

Acknowledgments

It's fabulous to experience a whisper of an idea turn into a completed book, but without the encouragement and assistance of many people, that whisper could have easily dissipated into the ether. I owe a lot of gratitude, and no doubt coffees or martinis (or both) to the following good folks.

Susan Rimerman, Ted Waitt, Cliff Colby, Nancy Aldrich-Ruenzel, Nancy Davis, Scott Cowlin, Sara Jane Todd, and everyone else at Peachpit Press encouraged this project and made it happen.

Mimi Heft designed the book and provided first-class templates in which I could work. Unlike many authors, I write directly into the book's layout using Adobe InDesign, so working in a template that's properly styled and professionally designed is a privilege.

My editing and production team, led by Susan Rimerman, made all the practicalities happen: Scout Festa made me wish I could write as fast and as sharp as she's able to copyedit my text; Karin Arrigoni managed the crush at the end of the project to produce a top-rate index; and Tracey Croom put her production talents to good use shepherding the laid-out files and keeping my work on the up-and-up.

Chris Morse and Chris Horne gave me access to early prerelease versions of their app Photosmith 2 so I could include it in the book.

Glenn Fleishman helped maintain my link to the outside world as virtual officemate—and occasional in-person lunch or coffee companion—and patiently listened to my laments and successes.

Agen G. N. Schmitz also put up with my electronic chatter, but more importantly wrote Chapter 8.

Dana and David Bos granted permission for me to use photos I've shot of their daughter, Ainsley.

Peter Loh provided invaluable photo studio equipment.

Tor Bjorklund donated the wood used in many of the studio photos.

The owners and staffs of Aster Coffee House and Herkimer Coffee here in Seattle provided great places to work when I needed to get out of my office, and happily took my money when I needed more coffee. Which was often.

Kim Carlson built the App Reference appendix and served as a fantastic photographer's assistant and propmaster, but most importantly kept me sane and supported this project starting with my first inkling of an idea.

And Ellie Carlson continues to serve as a great model and a good sport when I turn the camera on her. She'll thank me when she's older. Right?

Contents

Introduction

Photographers carry gear. It doesn't matter whether you're a pro with multiple camera bodies and lenses or a casual shooter with an ever-present point-and-shoot camera—there's always stuff to pack along. And if you're traveling or away from your office or studio, part of that gear typically includes a laptop for reviewing and backing up the photos you take. Too often I've heard friends who are about to go on vacation moan that they needed to bring a bulky computer just to handle their digital photos.

The iPad is changing all that.

Measuring less than half an inch thick and weighing about 1.3 pounds, the iPad is a fantastic device to take in the field. With the addition of the inexpensive iPad Camera Connection Kit, you can import photos directly from a camera or memory card and view them on the iPad's large color screen, revealing details that the relatively puny LCD on the back of your camera may obscure. More important, a rich array of photography apps and related products is adding to the list of things the iPad can do with those photos: rate and add keywords, perform color adjustments, retouch blemishes, and share the results online.

Oh, and don't forget all of the iPad's other capabilities: browsing the Web, accessing your email, reading ebooks, playing movies and music, and, as they say, so much more.

Can You Really Leave the Laptop Behind?

Although the iPad can do a lot that you would have needed a laptop to do just two years ago, there are still some important limitations that you should keep in mind when you decide whether a laptop stays at home.

If you're generating a significant amount of image data—over 32 gigabytes (GB)—then storage becomes a problem. As this book goes to press, the current highest-capacity iPad holds 64 GB. You can free up some memory by removing apps, music, videos, and the like, but if you're filling multiple 16 GB or 32 GB cards with photos, the iPad won't work as a repository of your shots. (But I detail several workarounds in Chapter 1.)

One solution is to buy a lot of memory cards and use them as you would film canisters. The originals stay on the cards, while the keepers remain on the iPad; you delete the ones you don't want as you cull through them. Fortunately, memory cards are inexpensive now. *Un*fortunately, they're small and easy to lose. Make sure you know where they are, label them accurately, and keep them protected.

If you capture raw-formatted images, you won't benefit from the same level of editing that a dedicated application on a desktop computer can offer. With a few exceptions, all image editing occurs on JPEG versions of the raw files, and exports as JPEG files (see Chapter 4 for more details).

So, to answer my question, in many circumstances yes, you can leave the laptop behind. If you're going to trek across Africa for four weeks, that's likely not realistic, but for most day trips or short vacations, the iPad makes a great companion.

Which iPad Should You Use?

If you don't already own an iPad, here are some guidelines for choosing one that will be a worthwhile addition to your camera bag.

For the reasons mentioned, I recommend getting the highest-capacity iPad that's available (and that you can afford). That gives you plenty of room to store photos and apps; some image editors make a copy of a photo to work with, so you could easily fill a couple of gigabytes just editing. Plus, it's an iPad, not just an extra hard disk, so you'll want to store music, movies, books, and all sorts of other media.

You also need to choose whether to buy a model that connects to the Internet via Wi-Fi only or that includes 3G cellular networking. For photographic uses, 3G isn't as important, because you're likely to burn up your data allotment quickly if you transfer images to sharing sites or to online backup sources like Dropbox. (And it's turning out that even when a cellular provider offers "unlimited" data plans, they're not really unlimited.) I personally find the 3G capability useful in general iPad use, but not necessarily for photo-related uses.

In terms of which iPad model to get if you don't own one yet, I'd argue for the latest model. As I write this, the successor to the iPad 2 is rumored to be just a few weeks away; it will most certainly offer better processing performance and hopefully more storage and internal memory, all good factors when working with photos. If you can buy an iPad 2 for a good price, it too is a great model for photographers (obviously, it's what I used in writing this book). The original iPad will also work, but as apps and the iOS advance, its processor—and especially its small amount of working memory—is going to start showing its age.

Notes About this Book

As you read, you'll run into examples where I've adopted general terms or phrases to avoid getting distracted by details. For example, I frequently refer to the "computer" or the "desktop" as shorthand for any traditional computer that isn't the iPad. Although the iPad is most certainly a computer, I'm making the distinction between it and other computing devices, such as laptops, towers, all-in-one machines, and other hardware that runs Mac OS X or Windows. When those details are important to a task, I note specific applications or computers.

I also assume you're familiar with the way an iPad works—using gestures such as taps and swipes, syncing with a computer, connecting to the Internet, charging the battery, and otherwise taking care of your tablet. If you're brand new to the iPad, allow me a shameless plug as I encourage you to buy my *iPad Pocket Guide* (also from Peachpit Press).

Don't be surprised when you frequently run across the phrase, "As I write this." Both the iPad and software useful to photographers are advancing rapidly. A great example is the app Photosmith 2, which was in its pre-beta testing stage while I wrote Chapter 3. Products that enable you to copy photos from the iPad to an external USB hard disk were also just starting to hit the market. And, of course, the successor to the iPad 2 was also on the (rapidly approaching) horizon.

To stay abreast of the changing field, be sure to visit the companion site for this book, www.ipadforphotographers.com, where I'll post updates and information related to the newest tool in your camera bag.

The iPad on Location

Through the years, I've hauled various laptops on vacations and business trips, and although the computers have gotten smaller and lighter over time, carrying one and its assorted peripherals still takes up a lot of space and weight. In contrast, the iPad's slim size and weight makes it an ideal traveling companion. As a photographer, you probably already carry a fair amount of gear. Wouldn't you like to lighten your bag further?

Instead of squinting at the LCD panel on the back of the camera, view your shots on the iPad's brilliant 9.7-inch screen and pick out details in the middle of a shoot that you may miss through the viewfinder. You can also use the iPad as a remote photo studio. Sort, rate, and apply metadata to the images while you're traveling, or edit and share them to your favorite social networks. And then, when you're back at home or in your studio, bring the photos into your computer, ready for further editing in Lightroom or other software. Whether "on location" is somewhere truly remote or just your back yard, the iPad can be your new photographer's assistant.

Shoot Raw or JPEG (or Both)?

Before stepping outside, it's important to figure out how you want to capture the images that will end up on the iPad. The question of whether to shoot images in raw format or JPEG format initially seems irrelevant to the iPad—the device can import both types. But choosing one (or both) leads to considerations that ripple through the entire iPad workflow. So let's take the time to look at this first. (The table below provides a quick overview of the discussion.)

Raw image files contain the unaltered information captured by the camera's image sensor, which provides much more data to work with when editing in a desktop program such as Adobe Photoshop, Adobe Photoshop Lightroom, or Apple's Aperture. In general, professional and intermediate cameras offer a raw capture option.

JPEG files, on the other hand, are processed within the camera before they're saved. Each image is color corrected, sharpened, compressed, and adjusted in other ways to create what the camera believes is the best image.

When brought into an image editor on the desktop, a JPEG file doesn't offer as much image data and therefore can't be edited as thoroughly as a raw file. For example, you're more likely to successfully pull detail out of shadow areas with a raw file than with a JPEG. All digital cameras can capture JPEG images; for some models, JPEG is the only choice.

Read on for an overview of the options. Although I assume you want to shoot raw if you're able to—after all, the ultimate consideration is usually image quality—some situations may call for you to switch formats.

	Import to iPad	Rate & Tag Images	Edit Images	Sync to Computer
JPEG	Fast	Yes	Yes, but limited image information is available. Quality starts out compressed. Edited versions are saved as copies.	Easy import into desktop software or folder
Raw	Slower	Yes	Not directly in most apps. Edits apply to the JPEG preview. Lose the full advantage of editing raw files.	Raw files are imported into desktop software; any edited versions (JPEGs) are imported separately.
Raw+ JPEG	Slowest; uses the most disk space	Yes; treated as one image	JPEG portion is edited, while raw remains untouched. JPEG is often better quality than auto-generated preview.	Bring raw files and edited JPEGs into desktop software; delete other JPEGs (depending on software).

Shoot JPEG

If your camera doesn't shoot in raw format, JPEG is your only option. You might also choose to capture JPEGs when you're deliberately shooting snapshots that need to be processed or shared quickly, or when you want to employ the simplest workflow (1.1).

1. Capture photos in JPEG format on your camera.

2. Import the photos into the iPad (discussed in detail later in this chapter).

3. Review the photos using the Photos app.

4. Optionally edit, rate, tag, or share pictures.

5. Synchronize the pictures to photo software on your computer when you're back at home or the office.

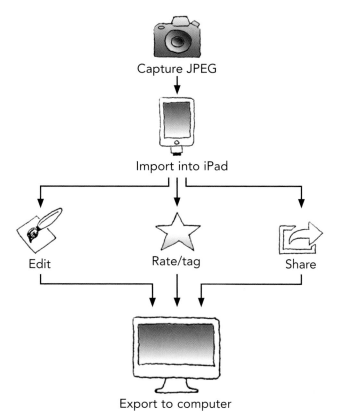

1.1 Workflow for shooting in JPEG format

Capture JPEG

Import into iPad

Edit Rate/tag Share

Export to computer

The main advantage of the JPEG workflow is that it's largely friction free. Photos occupy less storage space on the iPad, making even the lowest-capacity model (16 GB) workable for holding pictures on location. You also deal with just one set of images, unlike with raw files (as you'll see shortly).

The primary disadvantage is that JPEG images are compressed and corrected within the camera, so you're not getting the fullest possible image data. Editing images, whether on the iPad or on the desktop, further reduces image quality, because the JPEG format applies lossy compression—image data is removed from the file whenever it's saved. If you edit the images on the iPad, many editing apps apply still more compression when they output the corrected JPEG files. When you bring the photos into the computer, you don't have as much latitude for editing them.

I don't mean to sound alarmist, as if shooting in JPEG is going to produce muddled images or as if you need to go out and buy an expensive DSLR to end up with decent photos. JPEG compression is based on how the eye perceives images and is generally very good. It's just that, when compared to working with a raw file, JPEG files start you at a disadvantage.

Shoot Raw

Capturing photos in raw format adds some complexity to the iPad workflow (1.2). Although the iPad can import raw files, it can't edit them natively (in most cases; see Chapter 4 to learn about apps that *are* able to manipulate raw files directly). Instead, any editing or sharing is done on JPEG previews supplied by the camera.

1. Capture photos in raw format on your camera.

2. Import the pictures into the iPad.

3. If you edit or share photos on the iPad, the work is done on the JPEG previews. Edited versions are saved as new JPEG files, and the raw files remain untouched.

4. If you rate and tag photos using the app Photosmith, the metadata is retained when photos are exported from the iPad to the photo software on your computer (see Chapter 3).

5. Since any images you edited on the iPad are separate versions, they're added to your photo software. For images you didn't edit, the JPEG previews are ignored.

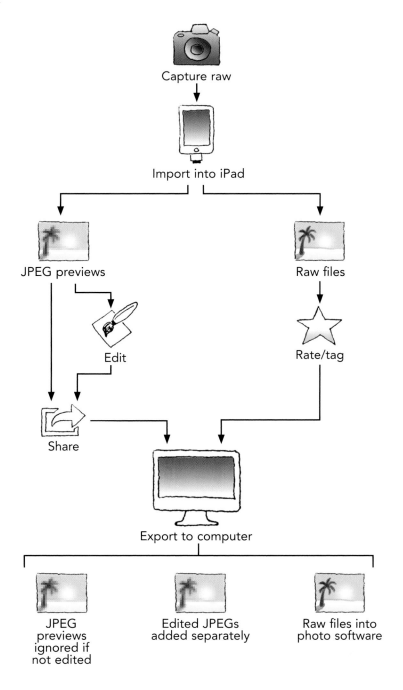

Capture raw

Import into iPad

JPEG previews

Raw files

Edit

Rate/tag

Share

Export to computer

JPEG previews ignored if not edited

Edited JPEGs added separately

Raw files into photo software

The advantage to the raw workflow is that you retain all of the image data for later editing, giving you the most flexibility with the photos on the desktop. Also, metadata that you add in Photosmith stays with the raw images when imported into Lightroom, so you don't need to undertake another round of rating and keyword tagging.

However, a main disadvantage is that raw files occupy much more storage space, which is an issue if you're shooting hundreds or thousands of photos. Most editing apps work only on JPEG previews, so you can't take full advantage of the raw image data unless you use a dedicated raw editing app. Also, unless the iPad is acting as just temporary storage between camera and computer, you end up with separate JPEG versions that must also be imported (unless you dump the JPEG versions).

Shoot Raw+JPEG

For cameras that support it, a third option is to shoot in Raw+JPEG mode. In this case, the camera writes two files: the raw file, plus a JPEG file as specified by the camera settings instead of an automatically generated preview file. The workflow looks something like this (1.3):

1. Shoot photos using the camera's Raw+JPEG mode.

2. Import the photos into the iPad, which displays just one thumbnail for each image and a "RAW+JPG" badge, although each image is made up of a raw file and a JPEG file.

3. Optionally edit and/or share photos, which applies to the JPEG counterpart for each photo. Edited images are saved as new JPEG files.

4. Rate and tag images in Photosmith. When you do so, the Raw+JPEG pair is treated as a single image.

5. Export the photos to your computer. The Raw+JPEG pair is treated as one image, although you can choose to work on the versions separately; Aperture, for example, gives you the option to import just the raw file, to import just the JPEG, or to import both files and specify which is the "master" for the pair.

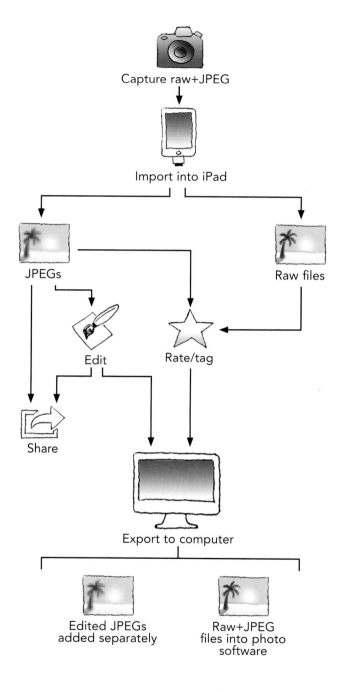

Capture raw+JPEG

Import into iPad

JPEGs

Raw files

Edit

Rate/tag

Share

Export to computer

Edited JPEGs added separately

Raw+JPEG files into photo software

On some high-end cameras that accept two simultaneous memory cards, you can specify that raw files be written to one card and JPEG files to the other. This implementation can be somewhat cleaner, treating the raw files as "digital negatives" that exist separately from the iPad (1.4):

1. Capture photos in Raw+JPEG format, specifying that raw files are written to one card and JPEG files are written to the other.

2. Import the JPEG images into the iPad. Leave the raw files on the card and store it in your camera bag.

3. Edit and/or share the JPEG files on the iPad.

4. Export edited versions of the JPEGs to the computer; delete the rest.

5. Export the raw files to your computer.

The primary advantage of shooting Raw+JPEG is that you have more control over the JPEG files that you import into the iPad. If your intent is to quickly preview and share photos from the iPad with a little editing here and there, and if you can save to separate cards, you can specify a smaller JPEG image size in your camera's settings. That speeds up import time and saves storage space on the iPad without affecting image quality much. Also, the raw originals are still available for editing on your computer.

The disadvantage is that you're taking up more storage space. If you're writing to separate cards and importing just the JPEG files into the iPad, you don't get the benefit of rating and tagging when you export the raw images to your computer.

Looking at these various options, I prefer to shoot just raw images and bring them into the iPad. None of my current cameras can record to dual memory cards, so shooting Raw+JPEG doesn't offer a compelling advantage to me.

(Not) Shooting with the iPad 2's Cameras

The iPad 2 introduced two cameras, front and rear, which are designed to work with the FaceTime video-conferencing app. You can also fire up the Camera app and take photos using the iPad…but please, unless you're really in a pinch, don't. The quality is surprisingly poor for capturing stills, not only in terms of resolution (0.7 megapixels for the rear camera, and VGA 640 by 480 pixels for the front one) but also in terms of overall image quality. I'm sure the next iPad models will boast improved cameras—there's really no other direction to go but up in this respect.

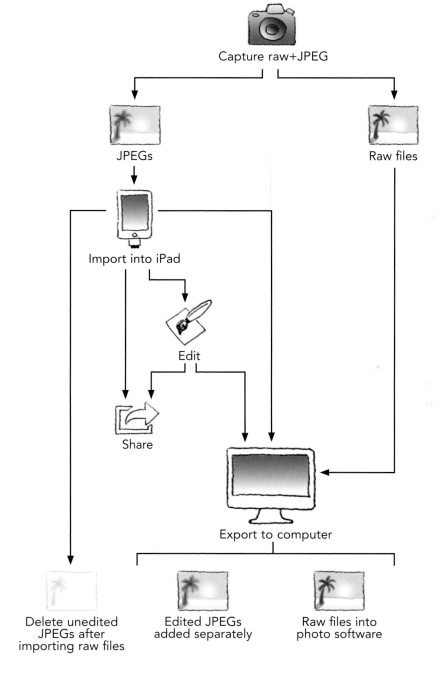

Capture raw+JPEG

1.4 Shooting Raw+JPEG using two memory cards

JPEGs

Raw files

Import into iPad

Edit

Share

Export to computer

Delete unedited JPEGs after importing raw files

Edited JPEGs added separately

Raw files into photo software

Review Photos in the Field

The shift from film to digital cameras brought an enhancement that fundamentally changed the way photographers shoot. It's second nature for us now, but the ability to take a shot and review it on the camera's LCD to provide immediate feedback was a real revolution. You could tell right away if you needed to adjust the exposure, you could check whether everyone in the shot was looking at the camera, and you could otherwise see what was just recorded to the memory card.

And yet. Camera screens have improved over the years, in both resolution and size, but it's not always easy to spot details on a 3-inch screen. The iPad's 9.7-inch screen, however, reveals plenty of detail, without involving the bulk and inconvenience of a laptop.

Using an inexpensive adapter from Apple, you can import shots from a memory card or from a camera directly and get a better view of your photos—while you're shooting on location, not later at home when the shot is no longer available. It's also possible to transfer photos to the iPad wirelessly using an Eye-Fi, a Wi-Fi–equipped memory card.

In this section, I'm making the assumption that you've left the computer at home and have the iPad on location—whether far-flung or just out and about for a couple of hours. There are times when you may want to review photos on the iPad even with a laptop available; I cover such situations in the next chapter, "The iPad in the Studio."

Import Using the iPad Camera Connection Kit

Apple's $29 iPad Camera Connection Kit is one of the few truly essential iPad accessories; without it, I wouldn't be able to write this book! The kit is made up of two pieces that attach to the iPad's dock connector: an adapter that accepts SD memory cards, and one that accepts a standard USB plug (1.5).

1.5 The two pieces of the Apple iPad Camera Connection Kit enjoying a sunset together

Import from a memory card or camera

When you're ready to transfer the photos you shot, do the following:

1. Remove the SD card from your camera and insert it into the SD card adapter. Or, connect the USB cable that came with the camera (typically a USB-to-mini-USB cable) between the USB adapter and the camera's USB port.

2. Wake the iPad if it's not already on.

3. Insert the adapter into the iPad's dock connector. If you're connecting via USB, you may also need to power on the camera or switch it into its review or playback mode. The Photos app automatically launches and displays thumbnails of the memory card's contents (1.6, next page).

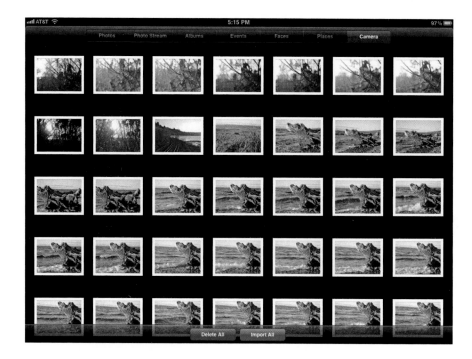

1.6 The contents
of a memory card

When importing Raw+JPEG images, the format is marked on their thumbnails (1.7). You can't choose whether to import JPEG or raw independently, though.

4. If you wish to bring in all of the photos, tap the Import All button. Otherwise, tap the thumbnails of just the photos you want; a blue checkmark icon indicates a photo is selected. Unfortunately, there's no option to view a larger version of the shots at this point. There's also no easy way to select a range of thumbnails other than tapping each one. iOS 4 actually included a great shortcut: touch and hold one photo, and then drag to select others without lifting your finger. That capability disappeared in iOS 5; I'm hoping it's a glitch and that the shortcut returns in a future software update.

5. Tap the Import button (1.8). You still have the opportunity to ignore your selections and import everything by tapping the Import All button. Or, tap Import Selected to copy the ones you chose in the last step. The photos begin copying to the iPad's memory; a green checkmark icon tells you the photo has been imported.

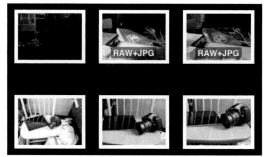
1.7 Raw+JPEG files are clearly identified.

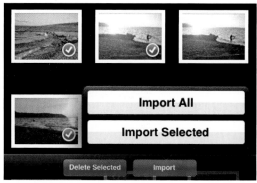
1.8 Import only the photos you want.

> ▶ **TIP** It can take a while to import a full memory card, but you don't have to put the iPad down. Photos continue to copy in the background, even if you switch to another app.

6. After the photos are copied, you're asked if you want to delete the imported files from the memory card. I recommend tapping the Keep button and then erasing the card using the camera's controls.

 The images appear in your Photo Library in two new, automatically created albums: Last Import and All Imported.

7. At this point, you can remove the adapter—no need to eject it, as you would on a computer. The Photos app switches to the Last Import album, where you can review the imported photos.

When the Photos app scans an inserted memory card, it identifies shots you've already imported with a green checkmark. For example, suppose you're shooting with the same card that you used yesterday because there's still plenty of free space left on it. If you tap the Import All button, you're asked if you want to re-import all of the photos—in which case you end up with multiple copies—or to skip the duplicates.

> ▶ **TIP** As you can see from the screenshots, the import process also gives you the option of deleting images from the memory card. This feature is great if you want to keep using a card for shooting but don't want to save obviously poor photos. For example, I don't need to retain dozens of test and setup shots while I'm trying to dial in the right settings and lighting positions. Tap to select the photos you wish to remove, and then tap the Delete button.

What About CompactFlash (CF) Cards?

You can connect the USB adapter to your camera, but of course that ties up your camera while the photos are downloading. Instead, plug the card into a CompactFlash USB reader and connect that via the USB adapter. However, there's a catch: It doesn't work with all readers. The iPad imposes a limit of 20 mA to the amount of power an accessory can draw. If the card reader requires more, it won't work (unless the reader is connected to a powered hub, and the hub is connected to the iPad; but a powered hub won't help you if you're on location without an electricity source). I can't recommend any particular models, since the market changes frequently, but a search for CompactFlash adapters for iPad will reveal models that other photographers have used successfully.

Import from an iPhone

While I was having coffee with a friend, he asked, "So, are you going to get the cool new camera?" I must have looked puzzled, because he followed up with a grin and, "You know, the camera that also has some smartphone features." He meant the iPhone 4S, which was about to be released. He was far less interested in the specifications or new features of the device than in the substantial improvements made to its camera.

That camera is quite impressive, made more so by the fact that the iPhone is always with me. I can capture great shots without also carrying a separate camera all the time.

Getting photos from the iPhone into the iPad is as simple as importing from any other digital camera. Plug a regular iPhone sync cable into the Camera Connection Kit's USB adapter, and then connect the iPhone and the iPad. Thumbnails appear in the Photos app, ready to be imported (1.9).

Another direct import route from iPhone to iPad (or between any two iOS devices) is to transfer the photos wirelessly using an app called PhotoSync. As long as both devices are connected to the same Wi-Fi network, they can bounce images back and forth, like so:

1. On the iPad, launch PhotoSync and tap the red Sync button.

2. Tap the Receive Photos/Videos button.

1.9 Importing photos from an iPhone into the iPad

3. On the iPhone, launch PhotoSync and tap the thumbnail of the image or images you want to transfer.

4. Tap the Sync Selected button.

5. In the next dialog, tap the iPhone-iPod-iPad button to specify where you want to transfer the image or images to (1.10).

6. Tap the name of the iPad that appears. The photo or photos you selected copy from the iPhone to the iPad.

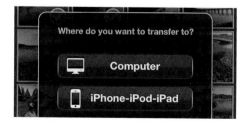

1.10 Transfer photos from an iPhone (shown) to an iPad using PhotoSync.

The Secretly Versatile iPad Camera Connection Kit

The USB adapter of the iPad Camera Connection Kit was designed to connect the iPad and digital cameras, but it works with other USB-based items, too. Need to type something lengthy but don't own a wireless keyboard? Plug in a USB one. Connect a wired USB headset and use the Skype app to talk to people via voice. Or, plug in a USB microphone, record to GarageBand or iMovie, and you have a portable podcasting studio (1.11).

There is one catch, though. As I mentioned in the "What About CompactFlash (CF) Cards?" sidebar, iOS imposes a 20 mA power limit on the USB connection. So, some accessories that draw more energy than that to function won't work. In that case, you need to connect the accessory to a powered USB hub. (One exception: I've seen some USB keyboards continue to function even after triggering the low-power alert.) Be sure to test any accessory before you go on location.

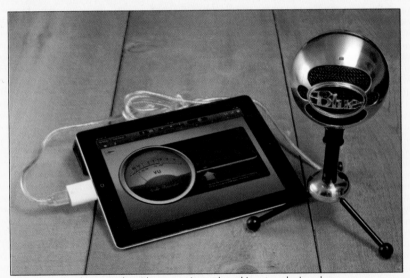

1.11 The USB adapter works with accessories such as this external microphone.

Import Wirelessly Using Eye-Fi Direct

Wait a minute. We're in the second decade of the twenty-first century, viewing high-resolution digital photos on a tablet computer operated by touch. Do we need to shuttle files using adapters and cables as if we were using floppy disks? Isn't there another way, one that feels more like the future we live in?

How about taking a photo and having it appear on the iPad a few seconds later, using the camera you already own and without tethering it to the iPad via a cable? Using an Eye-Fi wireless memory card, you can do exactly that. The Eye-Fi looks and works like a regular SD memory card, but it also features a built-in radio that can connect to Wi-Fi networks or even create its own.

When you're shooting on location, that latter detail is important. The Eye-Fi is known for being able to hop onto a Wi-Fi network and transfer photos to your computer on the same network, or upload images to photo-sharing sites such as Flickr, Facebook, or SmugMug. But that doesn't help if a Wi-Fi network isn't available. Eye-Fi's Direct Mode turns the card into a wireless base station inside the camera. After you connect the iPad to that Eye-Fi network, photos you shoot are copied shortly after they're captured.

As I write this, Eye-Fi sells cards in 4 GB and 8 GB capacities, ranging in price from $50 to $100. Although Direct Mode is available for each model, the high-end card, the Pro X2, is the only one that supports working with raw images.

Set up the Eye-Fi according to its instructions, which involves creating an Eye-Fi account, installing the Eye-Fi app from the App Store, and configuring the iPad to recognize the Wi-Fi network created by the Eye-Fi card. Then, insert the card into your camera and start shooting.

▶ **TIP** Some cameras now include built-in support for Eye-Fi cards. My Canon PowerShot G12, for example, recognizes when one is inserted and provides a menu of options specific to the Eye-Fi.

Shoot and import using Eye-Fi Direct Mode

Once the card and the iPad are set up, capturing and transferring photos works like this:

1. Take a photo to activate the Eye-Fi card's Direct Mode. (It goes to sleep after a few minutes of inactivity to conserve power.)

2. On the iPad, go to Settings > Wi-Fi and select the Eye-Fi Card network (1.12).

3. Launch the Eye-Fi app.

4. The test photo you just took automatically transfers to the iPad; any images on the card that had not yet been transferred are also copied.

5. Continue shooting. As you capture each shot, it's transferred to the iPad (1.13).

6. Tap a thumbnail in the Eye-Fi app to view the photo full-screen. (However, you can run into problems with raw files; see the next sidebar for more information.)

▶ **TIP** Change the iPad's Auto-Lock setting to 15 minutes or Never when you're shooting with the Eye-Fi (go to Settings > General > Auto-Lock). If the iPad goes to sleep, it severs the connection to the Eye-Fi's network to conserve power. When you wake up the iPad, it may not automatically grab the network again (especially if you took a break in shooting, during which the Eye-Fi goes to sleep).

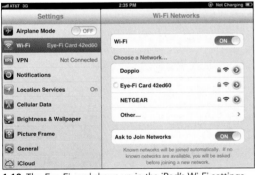

1.12 The Eye-Fi card shows up in the iPad's Wi-Fi settings.

1.13 Photos arrive in the Eye-Fi app from the camera just after they're shot.

Import Wirelessly Using ShutterSnitch

Unfortunately, the Eye-Fi app's support for raw files is spotty. When shooting with my Nikon D90 and Canon PowerShot G12, for example, raw files appear in the Eye-Fi app only as small thumbnails for browsing, even though the source files are stored in memory. I originally thought I could switch to the Photos app to view the file, but it sees the paltry thumbnail and uses that for display. So, one option in that situation is to shoot Raw+JPEG and review the JPEG versions.

Another option is to purchase ShutterSnitch, a $16 app that works with the Eye-Fi and can properly view raw images. (Make sure you disable the Accept JPEGs Only preference in ShutterSnitch's settings.) If you own an older Eye-Fi that doesn't support Direct Mode, ShutterSnitch can work with a portable wireless base station unit (like a Novatel Mi-Fi) to import photos.

ShutterSnitch is also a helpful photographer's assistant. It displays pertinent metadata (ISO, aperture, shutter speed, and focal length) and can pop up warnings about that metadata that you specify. One of my annoying shooting traits is to forget to reset ISO, so too often I've started shooting at ISO 800 (or higher) even in well-lit situations. In ShutterSnitch, I created a warning that appears when any photo arrives with an ISO higher than 200 **(1.14)**.

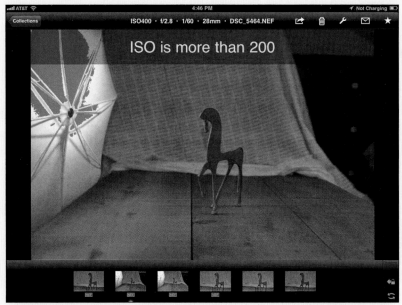

1.14 ShutterSnitch warns that my ISO is high and highlights hot areas of the photo (in red).

Back Up Your Photos

The main focus of this chapter is to move photos from your camera to the iPad, but getting them off the tablet in the form of backups is just as important. When you're shooting in the field with your iPad in hand, you don't have the luxury of transferring dozens of gigabytes onto your computer or to an external hard drive attached to it. That leaves you with a few options.

You can import photos into the iPad and use the memory cards you shot with as backups. It's like carrying film rolls all over again—although in this scenario, they occupy much less physical space. Fortunately, the price of memory cards has steadily dropped as capacities have increased, so you're not spending a lot of money to pick up several 8 GB or 16 GB cards.

However, one problem with that approach is the relatively limited capacity of the iPad. The current high-end model, with 64 GB of memory, feels like an airy, open orchestra hall when you're just loading apps and documents. But the walls begin to push in if you're capturing several hundred shots during each outing (and that's assuming you've minimized the amount of music and video being synced in order to make room for photos).

So, if the iPad itself isn't big enough to hold one set of photos, you need to get them off the iPad and onto another medium. If I were talking about an average computer, this step would be trivial: just copy the files to a hard disk. Alas, the iPad doesn't work that way. Since iOS doesn't expose its file system to users, Apple opted not to offer the ability to push files around between devices without a computer in the middle.

Of course, that doesn't mean the task is impossible.

Online Services

If your iPad can connect to a speedy Wi-Fi Internet connection, you can upload images to a service such as Dropbox or to Apple's Photo Stream feature of iCloud. I recognize that "speedy Wi-Fi Internet connection" can be a giant *if*. Maybe someday you'll be able to tap into a fast, high-capacity cellular network in a sheep pasture in Scotland, but chances are you'll be blissfully (or agonizingly) far from the rest of the world while you're shooting.

More likely, after shooting for the day, you return home or to a hotel room, or maybe park in a Wi-Fi–equipped coffee house for a few hours, and connect to a broadband Internet connection there (although even that possibility can be spotty, depending on location). Today's cellular networks are only starting to approach the speed and capacity required to upload dozens or hundreds of multi-megabyte files, and in most cases you pay a premium to do so.

But again, it's not impossible. I've uploaded large files for book projects while sipping in a Starbucks, and I've dribbled files over a flaky 3G cellular connection next to a tent and campfire in the North Cascades.

What's important is to have some type of backup. Everything I discuss in this book becomes useless if you somehow lose the photos you went to such trouble to capture in the first place.

▶ **NOTE** I feel I should reiterate that these aren't the swiftest methods of backing up photos, especially if you're talking about multi-megabyte raw files. But if the choice is between letting the iPad upload files for a while or losing photos, I'll always choose the backup route.

iCloud Photo Stream

I signed up for Apple's free iCloud service primarily to share my calendars and contacts between various devices, but I also got an added bonus: Photo Stream.

Whenever you take a photo using an iPhone, iPod touch, or iPad 2, it's saved to the device's Camera Roll. With Photo Stream enabled, each of those photos is automatically uploaded to iCloud and copied to your other enabled devices when they're connected to a Wi-Fi network. A photo captured by my iPhone, for example, shows up on my iPad, on my Apple TV at home, and on my MacBook Pro (when I launch iPhoto).

More importantly for our discussion here, any photos imported into the iPad using the Camera Connection Kit or an Eye-Fi are added to the Camera Roll, so they, too, appear in your Photo Stream (1.15). (The same applies to screenshots you capture on an iOS device, which often makes my personal Photo Stream quite the thrilling mix of photos, test images, and screenshots of those test images. Not quite the same emotional impact when playing slideshows for family.)

1.15 Photo Stream, shown in the Photos app

Photo Stream is great because you don't have to do anything special other than enable the service. (In the iPad's Settings app, tap the iCloud button, tap Photo Stream in the right column, and then flick the switch to On.) As long as you're connected to the Internet via Wi-Fi, the photos copy automatically to Apple's servers.

There are a couple of limitations, however:

- Photo Stream stores just 1000 pictures on the iPad. Once you reach that thousandth photo, the oldest images in the stream are removed in favor of new ones. On the iCloud servers, 30 days of photos are saved, giving you plenty of time to connect on your computer and download the pictures. Once on the computer, the photos aren't deleted.

- As of iOS 5.0, you can't delete pictures from the Photo Stream. So, if you import a flub from your camera, that file sticks around until it rotates out. (As I write this, there are rumors that an upcoming version of iOS may add the capability to remove images from Photo Stream. So, this point might be moot by the time you read this.)

If you do want to make sure a few photos stick around on the device, copy them from the Photo Stream to an album.

1. On the iPad, open the Photos app and tap the Photo Stream button.

2. Tap the Share button.

3. Tap to select one or more photos you want to copy to an album.

4. Tap the Add To button (1.16).

5. Tap Add to New Album, type a name for the album, and then tap Save. Or, tap Add to Existing Album and then tap an album (1.17).

 The photos are added to the album you created or chose.

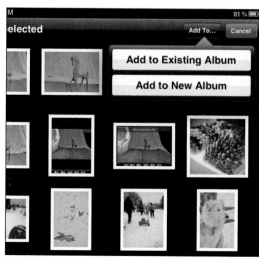

1.16 The Add To options

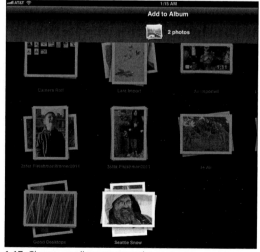

1.17 Choose an album to store the copies in.

Dropbox and similar services

If you're not using iCloud, or you want finer control over which photos are uploaded, consider using an online service such as Dropbox. It's a file storage service that has fundamentally changed the way I work on my computers, and it extends its features to the iPad with the Dropbox iOS app. (Another good option is SugarSync; I happen to use Dropbox, so I'll describe how it works here.)

On the Mac or under Windows, Dropbox creates a special folder that mirrors its content on the Dropbox servers. Anything you add to the folder is also copied to other devices you've set up with the Dropbox software. Here's a real-world example: Whenever I write a new article, I create it in an "Active Work" folder within my Dropbox folder. Each time I save the file, it's automatically copied not only to Dropbox's servers, but also to a Mac mini and a Windows PC in my office.

On the iPad (and other iOS devices), the file isn't copied automatically, because you may not want giant files to be pushed directly to a lower-capacity device. Instead, the Dropbox app is a window to everything stored in your Dropbox folder, letting you browse your files and download the ones you want to view. I can open my article in a text editor on the iPad and work on it, review PDFs, look at photos, and do pretty much anything else as long as I can download a file and own apps that work with the file formats.

Returning to photo backups, the Dropbox app can also *upload* files—files that you specify, not all files automatically—to your Dropbox. After you download and install the Dropbox app on the iPad, follow these steps to back up photos:

1. If you're uploading raw files, skip to step 2. If you have JPEGs, open the Dropbox app, tap the Settings button, and then tap Upload Quality. Change the Photo Quality setting to Original so the app doesn't compress your image. (You should only have to do this step once. Raw files are uploaded without compression, so this setting has no effect on them.)

2. Tap the Dropbox button in the upper-left corner of the screen, if you're viewing in portrait orientation; in landscape orientation, the list of files and folders in your Dropbox folder appears along the left edge of the screen. If you don't see the list, tap the ">" button at the upper-left corner to reveal the folders.

3. Tap the Uploads button.

4. In the popover that appears, navigate to the folder in your Photo Library that contains the files you wish to upload.

5. Tap to select the photos (1.18).

6. Tap the button under "Choose an upload location."

7. Locate the folder you want as the destination and tap the Choose button. Or, tap the Create Folder button to make a new folder.

8. Tap the blue Upload button to start transferring the files. When the copying finishes, the files are available at the Dropbox servers and on any of your computers connected to the Internet.

▶ **TIP** Dropbox offers 2 GB of storage for free, which is suitable for most people's document needs. Photos, of course, take up much more storage, so you'll want to consider paying for more storage. Paying $9.99 a month gives you 50 GB; $19.99 a month bumps that up to 100 GB. That's quite a jump, I know. I use the service enough that the 50 GB range is worth it for me, but I've also been told by reputable sources that if you contact the Dropbox folks directly, you can get less capacity for less money.

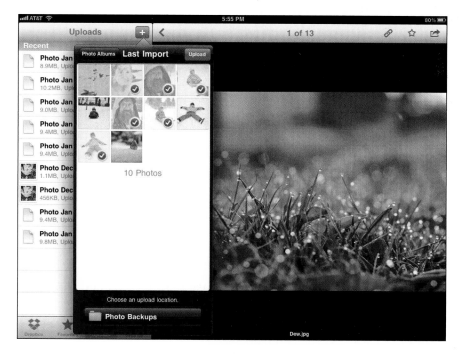

1.18 Choosing files to upload to Dropbox

Portable Storage

Until recently, the notion of copying your photos from the iPad to a portable hard disk was science fiction. Doing so makes sense: just offload your photos to a small disk connected via USB. But that would require a level of interaction with the file system that Apple is intentionally trying to obscure; when you're using an iPad, you're focused on tasks, not on shuffling files and figuring out where they're located.

Working with gigabytes of photos, however, begs for the capability to copy lots of files to a small, lightweight storage system. An external hard disk is almost a requirement for shooting on location with a laptop, so why not attach one to the iPad?

As I write this, I'm aware of one product that can make it happen.

Seagate GoFlex Satellite and Photosmith

Seagate's GoFlex Satellite is a 500 GB portable hard disk with built-in Wi-Fi. Originally marketed as additional storage for the iPad (so you could carry your movie library without having to fill the iPad's internal memory), the GoFlex Satellite can now also communicate with Photosmith 2.0 and store roughly 20,000 high-resolution photos. (See Chapter 3 for more about using Photosmith.)

After you've imported photos into the iPad and then brought them into Photosmith, do the following to copy photos to the GoFlex Satellite:

1. Select a collection or a group of photos in Grid view.

2. In the Services pane of the sidebar, tap the GoFlex button and make sure the drive is powered on and recognized by Photosmith.

3. Tap the Backup/Update Photos button (1.19). The files copy to the drive.

Any metadata you've applied in Photosmith (ratings, titles, keywords, and the like) are also copied (as XMP sidecar files). When you return to your computer, connect the drive and import the files into Lightroom.

> ▶ **NOTE** At the Consumer Electronics Show (CES) in January 2012, Sanho Corporation showed off a new product called CloudFTP, a portable Wi-Fi hotspot that connects to any USB hard disk to make it accessible to the iPad. They also demonstrated its ability to copy files to and from the iPad. As this book goes to press, the product is not yet shipping. I'll post more information at www.ipadforphotographers.com as I learn it.

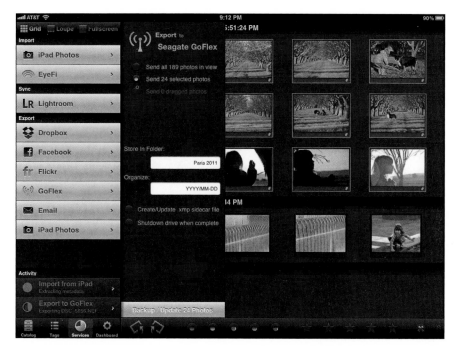

1.19 Copy photos from the iPad to a GoFlex Satellite external drive in Photosmith.

Use the iPad as a Fill Light

Most of this chapter has focused on using the iPad as a photo repository, whether you're importing pictures to review in the field or backing up the images for safekeeping. But there's another use for the iPad that doesn't require any data transfer. That 9.7-inch screen is backlit and bright, so feel free to use it on location to throw some illumination on your subject.

The screen can't replicate a strobe—you don't want to turn your retinas to ash by frying them while reading in bed, after all. But it is plenty bright, especially in dark situations.

The easiest way to set the iPad up as a fill light is to open an app that appears mostly white. Launch Safari and open a blank page, or run something like PlainText, a text editor, with a blank document loaded. Then angle the iPad so the illumination falls where you want it to.

1.20 The iPad, out of frame at left, acts as a fill light with a cyan-colored gel. It also reminds us to monitor caffeine intake among writers after midnight.

You can get creative with simulated gels by displaying various colors as background wallpaper images (1.20). Here's how:

1. In your favorite image editor on your computer, create an empty document and fill it with the color you want.

2. Save that image as a JPEG or PNG file.

3. Add the file to iPhoto, Aperture, or a folder on your computer that you use to sync photos to the iPad.

4. Open the iPad's Settings app.

5. Tap the Brightness & Wallpaper button.

6. Tap the Wallpaper button (which displays two background images: one for the lock screen and one for the home screen).

7. Select the photo you imported from the Photo Library.

8. Tap the Set Home Screen button to make that photo the background image on the iPad's home screen.

1.21 SoftBox Pro cooling the scene

9. Create a new screen of app icons: Touch and hold an app until the icons begin to shake, then drag it to the right edge of the screen until it's the only icon visible; press the Home button to make the icon stop shaking.

10. Position the iPad near your subject and take the photo.

A more elegant solution is to install the $2.99 SoftBox Pro app. It features several background colors, patterns (for adding custom catchlights), and a brightness control at your fingertips for quick adjustments (1.21). Choose the look you want, tap the screen to remove the controls, and get the shot.

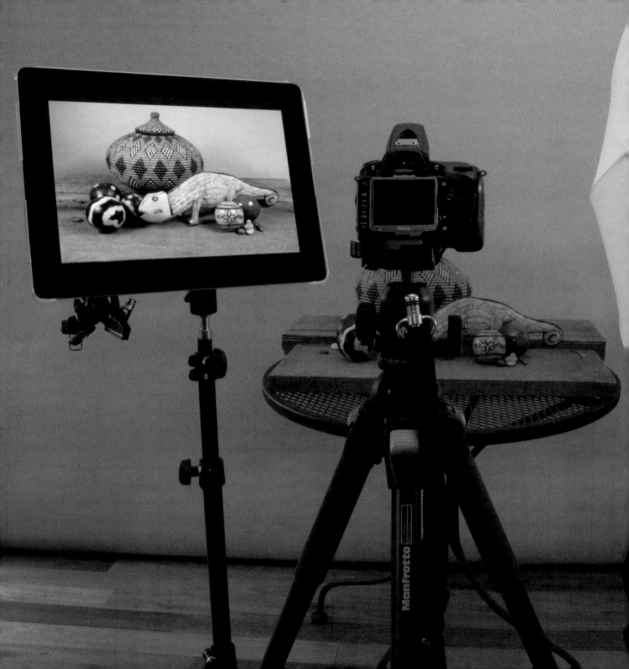

CHAPTER 2

The iPad
in the Studio

An iPad is a great photographer's companion in the field, but it doesn't have to sit dormant when you're back at home or in a studio. The techniques covered in Chapter 1, such as importing photos using the iPad Camera Connection kit or an Eye-Fi card, still apply when you're no longer on location. When you're not trying to minimize your equipment footprint, though, other possibilities open up.

The iPad can work alongside your camera and computer, triggering the camera shutter, providing clients or visitors a window to a photo shoot (without them peeking directly over your shoulder), or even controlling a remote iPhone or iPod touch to capture photos or create stop-motion or time-lapse movies.

Control a Camera from the iPad

Often when you're working in a studio, the camera is tethered to a computer. This arrangement allows you to import photos directly into software such as Lightroom or Aperture, review shots as they come from the camera, and skip the separate import step entirely. So where does the iPad fit in this situation?

Just because your camera is tethered doesn't mean you need to be. Especially if you're shooting products, food, or other compositions that require the camera to remain locked down, you can trigger the shutter, change exposure settings, and more from the iPad without touching the camera.

An iPad also works well when clients or others want to see your output as the photo shoot progresses. If it's inconvenient to have them hovering over your shoulder or the tethered computer, you can hand over the iPad and encourage them to relax on a couch situated a comfortable distance away from the camera. (Just remind them to keep their fingers off the button that fires the shutter.)

DSLR Camera Remote HD

OnOne Software's DSLR Camera Remote HD ($49.99) assumes most of the control over a tethered DSLR. (A $19.99 version for the iPhone or iPod touch is also available, which includes most of the same features except, of course, the iPad's large-screen preview.)

> ▶ **NOTE** Be sure to check onOne's list of compatible cameras to make sure DSLR Camera Remote HD will work with yours (www.ononesoftware.com/products/dslr-camera-remote/specs.html). Even if it's listed, some features may not work; my Nikon D90 can do Live View, for example, but not Video Mode.

Connect the camera and iPad

In addition to the iPad app, DSLR Camera Remote HD requires a free server application that runs on the computer; download DSLR Camera Remote Server from the onOne Web site (www.ononesoftware.com). With that in hand, do the following:

1. Make sure the computer and the iPad are on the same Wi-Fi network.

2. Connect your camera to the computer via a USB cable.

3. Launch DSLR Camera Remote Server on your computer (2.1).

4. Specify a folder on the computer's hard disk where photos are stored by clicking the Choose button under Download Location.

 OnOne recommends that you clear out that folder (by importing the files into your photo organizing software or moving them manually) to avoid overwriting between capture sessions.

5. Open the DSLR Camera Remote HD app on the iPad.

6. Tap the name of your computer in the list that appears. After a few seconds, the DSLR Camera Remote HD camera interface appears.

▶ **TIP** If you're having trouble connecting to the DSLR Camera Remote Server application on your computer, try turning Bluetooth off for nearby devices (the iPad, an iPhone, etc.). The short-range wireless technology could be causing enough interference with the Wi-Fi connection that a solid connection can't be made between the iPad and the computer.

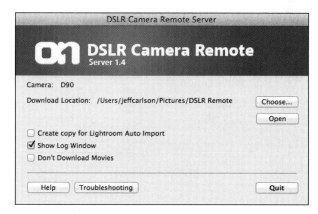

2.1 DSLR Camera Remote Server on the computer

The server app includes an option to make a copy of each photo and store it in a separate folder for automatic import into Photoshop Lightroom. Set up Lightroom's auto-import feature to watch that folder and import its contents when photos appear. (It sounds redundant to make a copy of each image file, but pointing Lightroom's auto-import feature at the DSLR Camera Remote HD folder moves the files, making them unavailable for review on the iPad.)

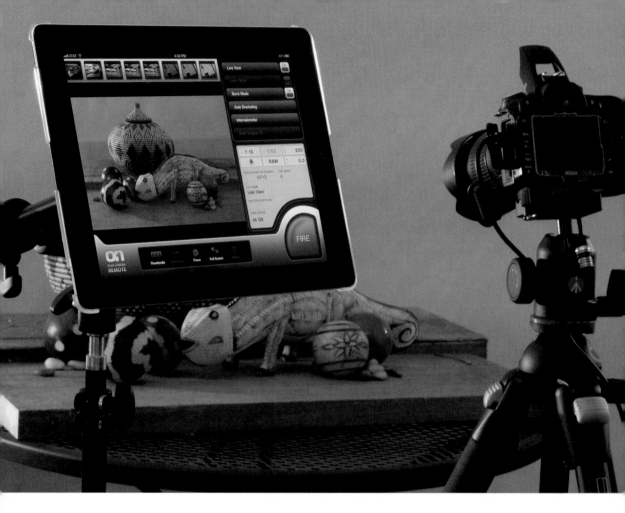

Compose and shoot

In many respects, your digital camera is already a computer, so why not use another computer to control the camera's settings and fire the shutter? With DSLR Camera Remote HD running, use the following controls (2.2). Some items can't be adjusted, depending on the camera model. Using my D90 as an example again, I can't change the exposure mode in software, because that setting is a physical knob on the camera. Also, as you would expect, the mode determines which settings are active—in shutter priority mode ("S" on Nikon models, "Tv" on Canon cameras), the aperture can't be set, because that's a value the camera calculates based on the desired shutter speed and ISO.

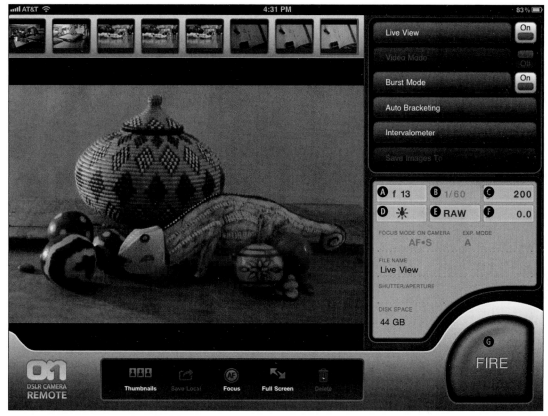

2.2 The DSLR Camera Remote HD interface

A. Aperture. Tap the current Aperture setting to choose an f-stop from the list of possible values. The popover that appears shows only the settings that are available to the current lens.

B. Shutter Speed. Tap the Shutter Speed button to specify how long the shutter remains open.

C. ISO Speed. Tap this button to choose a level of light sensitivity.

D. White Balance. Tap to select one of the color temperature presets.

E. Image Quality. Switch between available quality and format options.

F. Exposure Compensation. Choose from the range of positive and negative exposure adjustments.

G. Fire. Tap this giant button when you're ready to capture a shot.

Use Live View

On supported cameras, tap the On/Off button to the right of the Live View button to get a live feed of what the camera's image sensor is seeing.

The software can take advantage of the camera's auto-focus features: Tap the Focus button at the bottom of the screen, or tap the image preview. Unfortunately, you can't specify a focus area by tapping, as you can in the iPad's Camera app; doing so just relies on the camera's auto-focus mode. However, you can choose which focus priority is used (2.3):

1. Tap the Live View button (not the On/Off button).

2. Choose a mode:

 Canon cameras options are Quick Mode, Live Mode, or Live Face Mode.

 Nikon camera options include Normal Area, Face, and Wide Area.

3. Tap the Focus button to focus the frame.

Use Burst Mode

In Burst Mode, the camera captures a specified number of frames when you tap the Fire button once (2.4).

1. Tap the Burst Mode button.

2. Drag the slider to set the number of shots to take. The maximum number depends on the current Image Quality setting and your camera's image buffer; for example, shooting in JPEG format yields more shots than shooting in raw format.

3. Tap the Burst Mode's On/Off button to switch it to On.

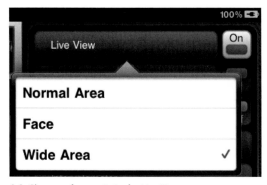

2.3 Choose a focus priority for Live View.

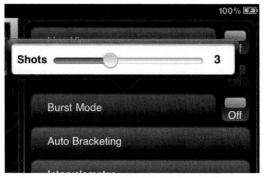

2.4 Set the number of frames to capture in Burst Mode.

Use Auto Bracketing

DSLR Camera Remote HD taps into your camera's ability to shoot a succession of three photos with different exposures (the current one, overexposed, and underexposed), a feature known as "bracketing." HDR (high dynamic range) images, for example, are created with three or more images at varying exposures.

1. Put the camera into its manual shooting mode.

2. In DSLR Camera Remote HD, tap the Auto Bracketing button to reveal the feature's options (2.5).

3. Drag the first slider to specify the variance in f-stops between each shot. The default is 1, which would give you an image at the current exposure, one at +1, and one at –1. The higher the value, the broader the difference in exposure will be in the set of shots.

4. Tap the next button to control whether the variance applies to full f-stops (Full Stop) or to thirds of a stop (1/3 Stop).

5. Set which variable is locked using the third control: Aperture, Shutter Speed, or ISO Speed. If Aperture is selected, for instance, the camera will adjust the shutter speed and ISO to achieve the exposure change, leaving your chosen aperture constant.

6. Drag the Delay slider if you want to pause between shots (to recharge a flash, for example).

7. Tap the Start button at the top of the popover to fire the trio of shots.

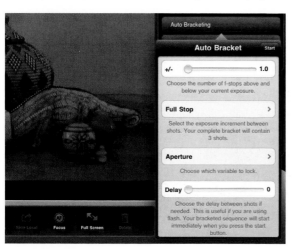

2.5 Auto Bracketing options

Shoot at specified intervals

DSLR Camera Remote HD includes an intervalometer, which captures a series of shots at a specified interval.

1. Tap the Intervalometer button (2.6).

2. Tap the Interval button, and choose the duration between shots in hours, minutes, and seconds (up to 23:59:59 for extreme time-lapse series of shots).

3. Tap the Number of Shots button, and enter a number in the text field to dictate how many captures are made at the interval.

4. Switch the Wait on First Shot option to On to pause before the initial capture.

5. Tap the Start button in the upper-right corner of the popover to start the Intervalometer.

▶ **TIP** The Intervalometer feature can double as a self timer: Set the Interval setting for the time you want before the camera fires, specify the number of shots as 1, and enable the Wait on First Shot switch.

2.6 Intervalometer controls

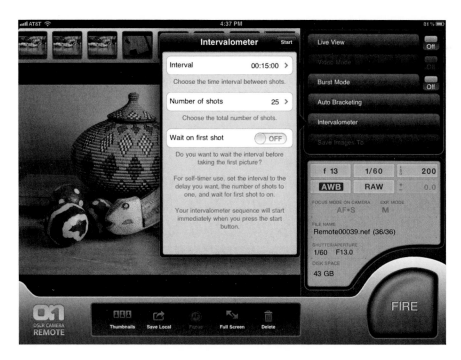

Record video

If your camera shoots video and is a model supported by DSLR Camera Remote HD, you can switch to Video Mode and direct the video capture from your iPad. (Visit onOne's Web site to check camera compatibility.) As with shooting in Live View mode, you can see what the camera is recording, start and stop the video capture, and tap to auto-focus. However, you can focus only before or after recording, not during capture. Also, you're not able to play back a video file on the iPad once it's recorded.

▶ **NOTE** Another intriguing app is ioShutter (www.ioshutter.com), which works with a custom cable that connects the iPad or iPhone to a DSLR or some supported prosumer compact cameras (like the Canon PowerShot G12). It offers timed shutter release, bulb mode, and time lapse features, controlled from the iOS device without requiring a computer in between. However, the cable is not yet available at the time of this writing, so I haven't used it.

Capture Pilot HD with Capture One

Another remote photo app is Capture Pilot HD (**2.7**), which works with Phase One's $399 Capture One software for Mac or Windows (www.phaseone.com). Capture Pilot HD is free to use with Capture One, allowing you (or a client) to view, rate, and tag images as they're captured. A $14.99 in-app purchase unlocks the ability to control the camera and shoot from the iPad. Although it offers many of the same features as DSLR Camera Remote HD, the Capture One software is much more comprehensive, serving as the environment in which you organize and process your photos. Capture Pilot HD also includes a live view, but it works only with Phase One or Mamiya Leaf digital back cameras.

2.7 Capture Pilot HD

Remote Shutter

I've focused on controlling a DSLR so far in this chapter, but if you own an iPhone, you already have a pretty good camera available. Remote Shutter, by iAppCreation, is an app that runs on the iPad and iPhone, connecting them both via Bluetooth. Choose one to act as the camera and one to act as the remote, and you can then fire the shutter; lock focus, exposure, and white balance; and set a timer (2.8). And, of course, it offers a range of filters to change the look of the captured photo.

2.8 Remote Shutter controls an iPhone (top) from the iPad (bottom).

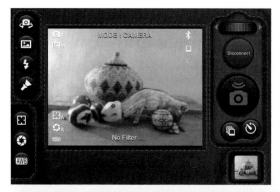

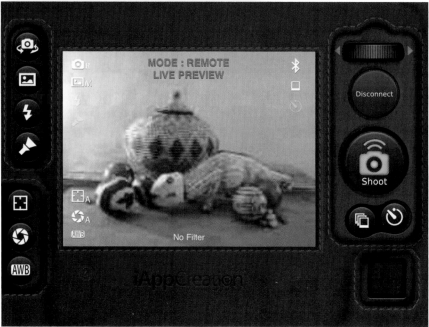

Mount the iPad

The iPad's portability can sometimes be a hindrance when you're shooting in the studio. Your hands are probably already full with camera gear—you don't want to set that down to pick up the iPad, or have to crane over a tabletop to view the screen without reflections from overhead lights. That's when mounting the iPad is useful.

Although there are no shortages of cases and stands for the iPad, I favor two options: a secure mount that was designed to integrate into a photographer's collection of stands and arms, and a simple desk mount that props up my iPad nearly all the time it's close to my computer. I encourage you to explore the market for options, which change often. For example, if you also dabble in music, a number of attachments designed for performance stands could also work to hold the iPad in place, to set it up as a teleprompter, to play relaxing music for clients or subjects, and for other uses.

Tether Tools Wallee System

The Wallee Connect system from Tether Tools (www.tethertools.com) consists of two parts: a case that connects to the back of the iPad (see the next page), and the Wallee Connect, a sturdy adapter that secures to the case and features holes and threads to connect it to tripods, heads, and lighting stands (2.9). The Connect Kit, which includes the case and the Connect, costs about $120.

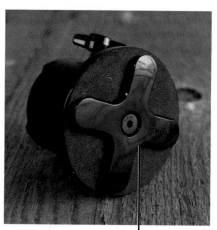

2.9 Wallee Connect

Threads for tripods and light stands

Locking mechanism

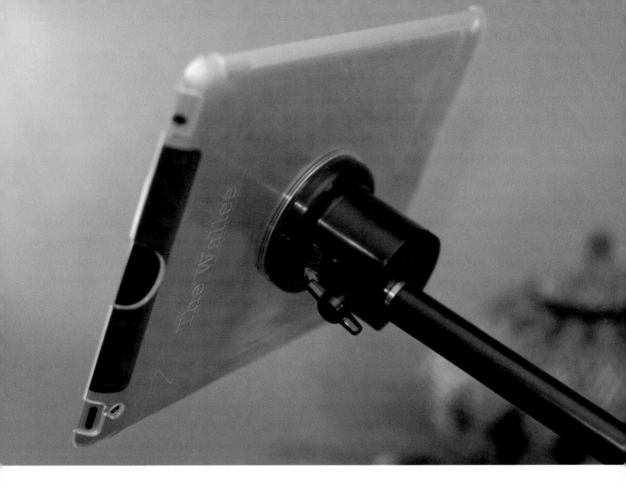

The Stump

Hundreds of iPad stands exist on the market now, ranging from simple plastic kickstands to large suction cups, but there's one that's proved invaluable to how I work. I often want to prop the iPad next to my computer or on a shelf or table near where I'm shooting. The Stump (www.stumpstore.com) is a $25 angled piece of heavy material covered in rubber that puts the iPad into three positions, in either portrait or landscape orientation (2.10).

It sounds almost too simple, I'll grant you. I received one in a bag of goodies for speaking at a conference and figured I'd toss it fairly soon. However, it's currently lifting my iPad 2 more often than the Smart Cover I bought. Whether it's for during a shoot or for working next to your computer later, the Stump is a great little addition.

2.10 The Stump is simple, portable, and quite useful.

Extend Your Computer Desktop with Air Display

Here's a neat way to take advantage of the iPad's screen real estate when you're back at your computer processing images: Set it up as a second display. Avatron's Air Display ($9.99, http://avatron.com) communicates between your computer and iPad via Wi-Fi to extend the computer's desktop **(2.11)**. Stash Photoshop panels on the iPad's screen to get them out of the way, or keep email and Twitter windows off to the side, leaving more space for working with your photos.

Speaking of Photoshop, the Adobe Nav app for the iPad can be helpful without invoking screen sharing. When running Photoshop CS5 or later on the computer, Adobe Nav ($1.99, www.photoshop.com/products/mobile/nav) accesses tools off to the side, offering more workspace on your computer.

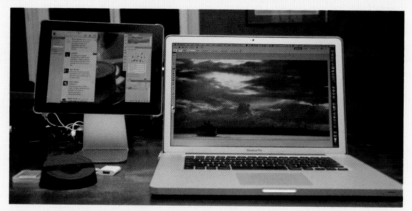

2.11 Use the iPad as an external monitor with Air Display.

Make a Stop-Motion or Time-Lapse Video

Since a studio offers a controlled workspace, you don't have to deal with the whims of natural light or environment. The DSLR Camera Remote HD app features an intervalometer for firing off shots at specific intervals, which can then be combined into a time-lapse video later. But here I want to focus on a clever app that makes the process of creating time-lapse or stop-motion videos easy on the iPad. iStopMotion for iPad by Boinx Software ($9.99) can use the iPad 2's built-in camera or an iPhone 4, iPhone 4S, or iPod touch (fourth generation) with the help of a remote app.

▶ **NOTE** Boinx also sells iStopMotion Home for the Mac for $49.99, which is a more comprehensive tool for shooting stop-motion and time-lapse movies.

Create a Stop-Motion Video in iStopMotion

Although you could use the iPad or an iPhone to snap a bunch of photos and then stitch them together later to make a stop-motion video, iStopMotion makes the process much less painless.

1. In iStopMotion, tap the New (+) button to create a new project.

2. Initially, the app activates the front-facing camera, so don't be surprised when your face suddenly appears. Tap the Cameras button at the top right area of the toolbar.

3. Choose the front or back camera.

 If you're using another iOS device as a remote camera, first launch the free iStopCamera app there. Then, on the iPad, select the name of the camera device. Lastly, tap the Accept button on that device to establish the connection. The camera's settings screen appears.

4. On the iPad or the other device, drag the Focus indicator to a spot where you want the focus to be locked (2.12). You can also tap the Exposure button at the top of the screen and identify an area on which to base the exposure level.

▶ **TIP** You'll want to shoot where the lighting is consistent, but also make sure you set the Exposure indicator to an area of the scene that's not likely to contain moving elements in your video; they'll throw off the color in those frames.

5. Tap Done to exit the camera settings screen.

6. Tap the Clip Settings button (the gear icon) to set playback speed (frames per second) and how the editing environment appears. Tap the Show button, which uses an "onion skin" mode to show the last frame and a ghosted rendition of the live video so you can see what the next frame will look like (2.13).

7. Set your scene, and then tap the Capture button to take a shot.

8. Reposition elements in the frame.

9. Tap the Capture button to grab the next frame.

10. Continue adjusting your elements and capturing photos until the scene is complete. Tap the Play button at any time to review what you've shot so far.

You can jump back to any frame to re-take it (make sure you line up your elements accurately), or you can delete a frame by selecting it, tapping the Actions button (the wrench icon at bottom right), and then tapping the Delete Frame button.

2.12 Lock focus in iStopMotion for iPad.

2.13 See the relative position of objects between shots.

Create a Time-Lapse Video in iStopMotion

Stop-motion animations require a lot of work and even more patience to do well. A time-lapse video, by contrast, needs just patience and an interesting enough place to point the camera. iStopMotion can automatically fire off a shot at an interval you choose, ranging from 1 second to 59 minutes and 59 seconds.

1. Set up your iPad, iPhone, or iPod touch where you want to capture action over a period of time.

2. Choose a camera from the Cameras popover.

3. Tap the Time Lapse button to the right of the Cameras button.

4. Make sure Time Lapse is selected under Mode (2.14).

5. Drag the minute and second dials to select an interval, then tap outside the popover to dismiss it.

6. Tap the Capture button to start capturing the scene. The button doubles as a countdown timer while waiting for the next shot (2.15).

7. Tap the Capture button again to stop recording frames.

▶ **TIP** Tapping anywhere near the Capture button works, too—you don't have to hit the button perfectly centered.

2.14 Specify Time Lapse settings.

2.15 The Capture button counts the time to the next shot.

CHAPTER 3

Rate and Tag Photos

Even if I were to do nothing else with photos on my iPad, I would want to perform my first round of rating and keyword tagging. I'd much rather spend time in front of my computer editing the photos than sorting them, especially since rating and tagging can be done with the iPad during downtime like waiting for a flight, chilling out in a coffee shop, or sitting on the couch in the evening.

Actually making that possible, however, is a difficult task, which explains why there are only a few apps capable of doing it. The one I'm focusing on is Photosmith by C^2 Enterprises, which lets you rate photos you've imported, assign keyword tags, and then sync to Adobe Photoshop Lightroom. Taking a slightly different approach, Code Foundry's Pixelsync pulls photos from Apple's Aperture or iPhoto, lets you work with them on the iPad, and then puts them back onto the computer festooned with metadata. Several image editing apps also now offer tools for rating and tagging.

Rate and Tag Using Photosmith

Apple introduced the iPad Camera Connection Kit at the same time as the original iPad. In the two years since, we've seen all kinds of software innovations with Apple's tablet, but surprisingly, being able to rate and tag photos hasn't quite succeeded until now. It seems like a natural request: Take the images you imported onto the iPad; assign star rankings to weed out the undesirable shots and elevate the good ones; add important metadata such as keywords; and, lastly, bring the photos and all that data into a master photo library on the computer.

Photosmith 2, in my opinion, finally delivers those capabilities. When you're shooting in the field, you can act on those photos instead of keeping them in cold storage. Back at the computer, that work flows smoothly into Photoshop Lightroom, so you don't have hours of sorting ahead of you.

Import Photos

When you launch Photosmith, it scans your iPad's Photo Library and displays thumbnails sorted by the photos' capture date (3.1). Tapping one of the Smart Collections buttons in the sidebar narrows the field; for example, I often want to just work with the Last Imported collection.

An Important Note About Photosmith 2

While I was writing this book, C² Enterprises was hard at work preparing version 2.0 of the app. Because the update offers several significant new features, such as the ability to batch-assign keywords, I realized I needed to abandon my original coverage of version 1.0 and jump on the new edition. However, the deadline for finishing the book was scheduled before the release of the software, so the developers were gracious enough to provide me with pre-release builds of Photosmith 2.0.

Although the functionality I describe should match the shipping version of the software, it's possible that some interface elements (or features) may have changed during the time the book was being printed and distributed. I plan to update this chapter once the release version of 2.0 is available, which should be by the time you read this; go to www.peachpit.com/ipadforphotographers to register your purchase and download the free, updated chapter.

3.1 Photo library in Photosmith 2

▶ **TIP** If, for some reason, you don't want Photosmith to scan your library automatically, you can turn that feature off. Tap the Services button at the bottom of the sidebar, then tap the iPad Photos button under Import, and switch the feature to Manual. The next time you add photos to your iPad, you would then need to return to the iPad Photos drawer and tap the Import Now button. This control also lets you include only specific photo albums from your library.

Photosmith can also import photos directly from an Eye-Fi card. Go to the Services pane, tap the Eye-Fi button, and set the service to Enabled.

Rate Photos

As you'll learn in the pages ahead, Photosmith features several ways to organize and group your photos. But let's start with the most likely first action: reviewing and rating the images you imported. The app supports ratings (1–5 stars) and color labels that track with those features in Lightroom. You can also mark photos that don't make the cut as rejected.

3.2 Rating a photo in Loupe view

QuickTag bar

To rate photos, do the following:

1. Double-tap a thumbnail to expand the photo in Loupe view.

 You can also tap the Fullscreen button to hide the sidebar and review each photo larger. Pinch to zoom in or out to view more or less detail.

2. Tap a star rating on the QuickTag bar to assign it to the photo (3.2). Or, if the shot isn't salvageable, tap the red Reject (X) button to mark it as rejected.

3. If you use colors to label your shots, tap one of the color buttons.

4. Use the Rotate buttons to turn photos that arrived with incorrect orientation in 90 degree increments.

5. Swipe left or right to switch to the next or previous photo.

6. Continue until you've rated all the photos you want.

 To return to Grid view, tap the Grid button; the photos are marked with stars to indicate their ratings (3.3).

3.3 Ratings and color assignments appear on thumbnails in Grid view.

3.4 The filter controls in the expanded QuickTab bar include buttons to select all thumbnails or none, or to invert the selection.

The values of the stars are up to you. My approach is to rate anything that looks promising (which sometimes means, "Oh hey, that one's in focus after all!") as one star. Photos that strike me more creatively get two stars. On rare occasion I'll assign three stars at this stage, but usually I reserve stars three through five for after I've edited the photos in Lightroom.

Rate multiple photos simultaneously

For an even faster initial review pass, you don't need to enter the Loupe or Fullscreen views. Select the photos you want to rate or categorize in Grid view, and apply the information at once, like so:

1. In Grid view, tap once on a photo to select it. Tap to select others.

2. Tap the rating or color label in the QuickTag bar to apply it to each selected photo.

3. To let go of your selections, you can tap each one again, but there's a better way: Swipe up on the QuickTag bar and tap one of the selection buttons—All, None, or Invert **(3.4)**.

Assign Keywords

In the interests of speed and convenience when reviewing photos, one task that's often ignored is assigning keywords to the images. On the computer, it's a mundane but important task (especially if you've ever found yourself trying to find an old photo and ended up just scrolling through thousands of shots); on the iPad, it was darn near impossible to do until only recently. Photosmith makes it easy to apply tags to a single photo or to all photos you've selected.

Assign existing keywords

If any of your photos already contain keywords, Photosmith pulls that information when it first scans your library. So, most likely, you'll start with a populated list of keywords.

Bring up a photo in Loupe view or select one or more photos in Grid view, and then do the following:

1. Tap the Tags button in the sidebar.

2. Tap the Keywords field to bring up the Keywords editor (3.5).

3. To assign an existing keyword, locate it in the list on the left and tap its button. You can also choose from the lists of Recent and Popular keywords that appear to the right.

 To quickly locate a keyword, begin typing it in the Search field at the top of the screen.

4. Tap Done when you're finished.

3.5 The Keywords controls

Create new keywords

The Search field also acts as the control to define new keywords. As you type, in addition to listing matches to existing terms, the text also appears under a Create New Keyword heading. Tap the tag that appears to add it to the selected photo or photos and to the keyword list.

Build keyword hierarchies

Keywording is a form of organization, and organization varies from person to person. While I prefer a single list of tags, you may be more comfortable with multiple levels of parent and children terms. Photosmith caters to both styles, letting you build keyword hierarchies that Lightroom understands, like so:

1. With the Keywords editor open, tap the Detail (>) button to the right of any tag to set that tag as the parent.

2. Type the name of the child keyword in the Search field. As the child keyword appears under the Create New Keyword section, Photosmith notes that it will belong to the parent tag (3.6).

3. Tap the new keyword to add it to the list and to the selected photo or photos.

Remove keywords

Suppose you mistype a keyword or apply it to a term by accident. To remove a keyword from those already applied to a photo, tap and hold it and then tap the Remove button (3.7). Or, if you want to just remove a keyword from the hierarchy, swipe left to right over it and tap Delete.

3.6 Creating a new child keyword, "winter," under "farm"

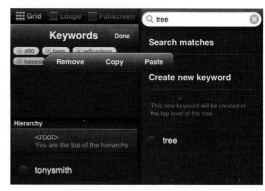

3.7 Removing a keyword from a photo

▶ **TIP** When multiple photos are selected and some contain keywords that are missing from the others, an asterisk (*) appears on any term that isn't shared by all. To quickly add it to the rest of the group, tap and hold the keyword and choose Apply to All from the group of commands that appears.

Edit Metadata

Keywords are essential for locating your images later and for assigning terms that can be found in photo-sharing services and commercial image catalogs, but you should also take advantage of other metadata while you're processing your photos in Photosmith.

With one or more photos selected in your library, go to the Tags panel of the sidebar and tap any field to enter text **(3.8)**. The Photo Title and Caption fields, for example, are used to identify images on Flickr and other sites. The IPTC fields are also important, because they embed your contact information, copyright statement, and job-specific metadata into the image file.

▶ **TIP** Set up metadata presets so you don't have to enter common information (like Creator and Copyright) for every photo. Create a new preset in the Tags pane of the sidebar, and then populate the data to as many photos as you'd like with just a few taps.

3.8 Add metadata to multiple selected photos.

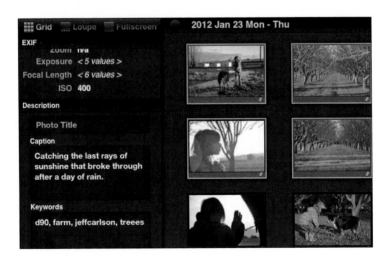

Filter Photos

Now that you've rated and tagged the photos and applied metadata to them, you can take advantage of Photosmith's filtering tools to customize which images appear based on all that information. Swipe up on the QuickTag bar to reveal the filtering options.

▶ **NOTE** Naturally, you don't need to apply every last bit of metadata before you can start filtering your library. Particularly when I want to share something online quickly, I'll do a pass of reviewing and rating my imported photos and then filter that group to view just my two-star picks. But for the purpose of explaining how the features work, it made sense to cover it all before talking about how to filter against it.

Filter by metadata

Here's where that rating and tagging pays off on the iPad. To display photos that match certain criteria, do the following in Grid view:

1. Swipe up on the QuickTag bar to reveal the filter options.

2. Tap the Filters button to reveal more specific filter controls.

3. Tap the criteria you wish to filter against (3.9). Selecting a star rating, for example, displays only images matching that rating. You can also filter by color labels and rejected status, or you can enter text that would match titles, captions, or keywords.

4. Tap Done to apply the filters.

5. To toggle filtering on and off, tap the button to the left of the Done button.

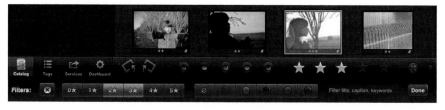

3.9 Using filters to view only photos marked with two or three stars

Filter using Smart Groups

Here's an issue I run into often when importing photos into Lightroom. The pictures on my memory cards tend to span several events, or even days if I haven't been shooting regularly. Lightroom sees the photos as one big collection, regardless of their contents. If I want to split them out into groups—and more importantly, apply accurate metadata during import—I need to bring them over from the camera in several batches.

Photosmith's Smart Groups feature enables you to view those photos in separate batches, adjusted on the fly using a simple slider control. Even if the photos cover one larger event, it's likely they represent distinct experiences. For example, when I'm on vacation I don't usually sit around and shoot in one place. I could be fly-fishing in the morning, sightseeing in town in the early afternoon, hiking later in the day, and waiting for the sunset at a scenic overlook in the evening.

When I bring the photos I took during that day into the iPad, I get them all in one event based on the date they were shot. Even importing in batches doesn't help, because I end up with just the iPad's Last Imported and All Imported smart collections, not the groupings I prefer (and I can't assign metadata anyway).

A better and faster workflow instead works like this:

1. Import all the photos into the iPad.

2. In Photosmith, swipe up on the QuickTag bar to make the Smart Groups slider visible (3.10).

3. Drag the slider to the left to break the library down into finer events (3.11). Or, to group more photos together, drag to the right.

Although this grouping doesn't change the locations of the files in the Photos app—they're not put into new albums or anything like that—it does give you the oppotunity to select ranges of photos by tapping the button to the left of the date stamps. Then you can apply ratings and keywords in batches that better match the grouping of real-life events.

▶ **TIP** The Smart Groups slider doesn't have to be tied to capture dates. It takes its cues from the Sort criteria that are to the left of the slider (and discussed in more detail two pages ahead).

3.10 The Smart Groups slider at its default position

Smart Groups slider

3.11 Selecting a finer setting (drag to the left) breaks the shoot into groups. In this case, the different stages of a birthday party are split apart: riding a pony, eating cupcakes, and then grooming the horses.

Change the sort order and criteria

Normally, photos appear in Grid view based on their capture date, with the newest additions at the bottom of the list. To change the order in which they appear, or to list them by import date, star rating, or color label, do the following:

1. Swipe up on the QuickTag bar to reveal the filter options.

2. To toggle the sort order between descending and ascending, tap the arrow to the right of the Sort button (3.12).

3. Tap the Sort button itself to reveal more sorting options.

4. Tap the button for the sorting criterion you wish to use (3.13).

5. Tap Done to go back to the filter options.

Working with Rejected Photos

Marking a photo as Rejected isn't the same as deleting it. When you reject a photo, it's still present in the catalog. And, in fact, you can't delete it from within Photosmith: To protect your data, Apple prevents third-party applications from deleting files that don't directly belong to them. Although Photosmith could, in theory, move the rejected photos to a new album in the Photos app to make it easier to find them, that solution also doesn't pan out, because deleting a photo in an album only *removes* it from that album. Unless you want to poke through your library in the Photos app to hunt down rejected photos, it's better to let them sync to Lightroom and delete them there.

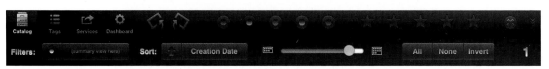

3.12 Swipe up on the QuickTag bar to reveal the filter options.

3.13 Tapping the Sort button reveals more sorting options.

Group Photos into Collections

I mentioned earlier that people organize photos in different ways—and that includes how they group photos. For some, having metadata in place is good enough to locate photos using filters and searches. Other people prefer to store images in albums, folders, or other types of digital shoeboxes. Photosmith's collections scratch that itch, giving photos an address within the app where they can be easily found, versus being scattered throughout the larger library. (Collections also play an important part in syncing between the iPad and Lightroom, as I'll discuss shortly.)

Follow these steps to add photos to a collection:

1. Select the photos in your library that you want to include in a collection.

2. If you need to create a collection from scratch, tap the New Collection button and give the collection a name.

3. To add the selected photos to the collection, take one of two actions:

 - Drag one of the photos onto the collection's name in the sidebar; all selected photos will accompany it.

 - Tap the collection's Detail (>) button to view its options in the sidebar drawer, and then tap the Add Selected Photos button (3.14).

Deleting photos from a collection is just as easy: Select the photos you wish to remove, tap the collection's Detail (>) button, and tap the Remove Selected Photos button.

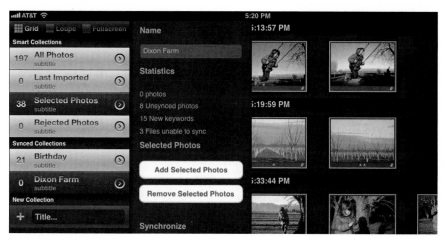

3.14 Adding selected photos to a collection using the sidebar drawer

Sync with Photoshop Lightroom

And now we get to the whole point of using an app like Photosmith. Rating and tagging is helpful, but if you can't transfer that metadata with your photos to Lightroom, all the work you put into it ends up being futile. Photosmith offers two methods to synchronize your images and data.

Photosmith publish service

Lightroom's Publish Services panel lets you sync photos to your libraries on Flickr, Facebook, and others. Photosmith takes advantage of this conduit, enabling two-way synchronization between the iPad and the desktop. Download the free Photosmith plug-in at www.photosmithapp.com, and install it in Lightroom using the Plug-in Manager.

Any collections you create in Photosmith show up in Lightroom as well, and the photos and metadata remain in sync when you click the Publish button in Lightroom (3.15). Or, synchronize a collection from within Photosmith by tapping its Detail (>) button and then tapping the Synchronize Now button (3.16).

▶ **TIP** The Photosmith publish service includes options such as specifying image size and format and applying Lightroom metadata presets.

3.15 Photosmith's collections appear in Lightroom.

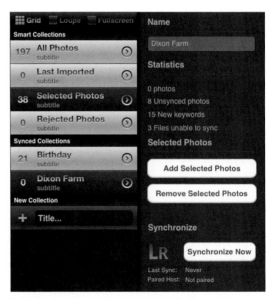

3.16 Synchronize a collection from within Photosmith.

Photosmith Plug-in Extras

If you'd prefer to transfer photos one-way from Photosmith to Lightroom, use the Plug-in Extras functionality:

1. In Lightroom, choose File > Plug-in Extras > Photosmith, and then choose one of the following options:

 - Sync Keywords: Transfers only the keyword list.

 - Sync Multiple Collections: Transfers one or more collections that you choose.

2. Click the Sync Now (for keywords) or Sync Collections Now (for collections) button to perform the transfer (3.17).

3. Click Close to exit the dialog.

3.17 Sync just the collections you choose from Lightroom.

Export to Photosmith

If that isn't enough options, you can also set up Photosmith as an export target. In Lightroom, choose File > Export and then specify Photosmith from the Export To menu. You can specify the image format and size, and you can choose whether to sync keywords for the entire library (slower) or just the keywords in use by photos (faster). The export settings can also be set up as a preset for easier export later.

▶ **TIP** Want to speed up Lightroom import? Of course you do! Here's a clever way to copy your photos faster. When you get to your computer, connect the iPad via USB (even if you normally synchronize over Wi-Fi), and use Lightroom's standard import process to pull the photos from the Photo Library; transferring files over USB is much faster than over Wi-Fi. Next, use the Photosmith publish service in Lightroom to sync it with Photosmith (or initiate a sync from Photosmith). The sync copies only the metadata between iPad and computer; it doesn't re-copy the image files.

Sync to a Hard Disk

Although Photosmith was designed to work with Lightroom, you can still take advantage of its features if you don't use Adobe's software. Export your tagged photos to your computer for later processing in other software. Photosmith offers two paths for doing this.

Dropbox

If you're on a robust Internet connection, copy images from Photosmith to Dropbox, which makes them automatically appear on any computer on which you're running the online service.

1. Select the photos you want to transfer.

2. Tap the Services button at the bottom of the sidebar.

3. Under Export, tap the Dropbox button to reveal the Export to Dropbox drawer (3.18).

4. Choose which photos to send (such as "Send 24 selected photos").

3.18 Send photos to your Dropbox account.

5. Tap a button under Upload Size if you want to resize the photos.

6. If you want metadata saved in separate files alongside the image files, select the Create XMP/Sidecar button. Metadata is also written to the image files themselves.

7. Tap the Send Photos button to start copying.

Seagate GoFlex Satellite

Seagate's GoFlex Satellite is a portable hard drive that also includes the ability to create its own Wi-Fi network. The Satellite was designed for people who want to carry a lot of media but don't have a high-capacity device. You load up the drive with your entire movie collection, connect your iPad (or iPhone, iPod touch, laptop, or whatever) to the Satellite's Wi-Fi network, and then stream the content. No syncing, no juggling media files to make room—simple.

Photosmith takes that concept and pushes it in the opposite direction. Apple makes it impossible to copy files to a device connected via the USB portion of the Camera Connection Kit, but that limitation doesn't extend to the air surrounding the Satellite. Copy your photos from Photosmith to the drive, with ratings and keywords intact, and then import them into the software of your choice.

1. Press the power button on the Satellite to start it up and activate its Wi-Fi network.

2. On the iPad, go to Settings > Wi-Fi and select the name of the Satellite's network.

3. Switch to the Photosmith app.

4. In the Photosmith catalog, select the photos you want to copy.

5. Tap the Services button in the sidebar.

6. Tap the GoFlex button to view options for the GoFlex.

▶ **TIP** You can also drag the selected photos to the GoFlex button to bring up the drawer that contains the export options.

7. At the top of the drawer, choose which photos to send (all viewed, selected, or dragged).

8. Specify a folder on the drive where the photos will reside.

9. To save the metadata in separate related files, select the Create/Update XMP Sidecar File button.

10. Tap the Backup/Update Photos button to initiate the transfer (3.19).

Back Up to Seagate GoFlex Satellite

If you own a GoFlex Satellite and Photosmith, you have one of the most valuable things a photographer shooting on location could ask for: a backup. In Chapter 1, I discuss options for keeping backups of your valuable image files; being able to wirelessly dump them to a portable hard disk circumvents all sorts of potential trouble, such as trying to find good Internet access to upload shots. If you're paranoid, buy two Satellites for a redundant backup.

3.19 Copy photos wirelessly to a GoFlex Satellite drive.

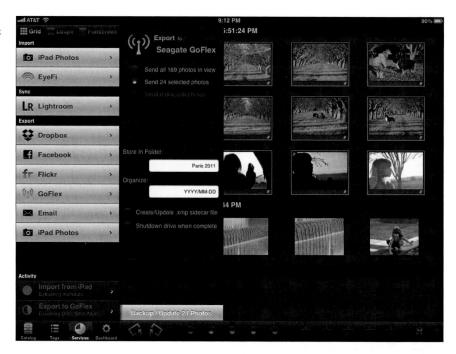

Rate and Tag Using Pixelsync

Every application starts with assumptions. Photosmith assumes you're importing photos directly from the camera and preparing them for the eventual transfer to the computer. Code Foundry's Pixelsync assumes your images are aleady on the computer and that you want to take them along on your iPad to sort and rate when you're out and about—think of it as the reviewing environment you work on during the bus ride to work. In fact, it entirely ignores the photos stored in the iPad's Photo Library. When you're finished reviewing, the expectation is that you'll bring your metadata back to the computer. If you store photos in Aperture 3 or iPhoto '11 (or later versions of each), Pixelsync is an elegant way to work on them without being tied to your Mac.

▶ **TIP** Pixelsync works with *both* Aperture and iPhoto, not just one or the other. In the Pixelsync Helper on your Mac, go to the application's preferences and add both library files to the Libraries list. Then, in Pixelsync on the iPad, choose whichever library you want in the Select Library dialog.

Import Photos

In addition to the Pixelsync app for the iPad, you need a small utility called Pixelsync Helper to direct communications between the iPad and the Mac. Download it for free at www.pixelsyncapp.com. Once it's installed and set up (you'll need to specify where your Aperture or iPhoto library resides), do the following to import photos from the computer into the iPad:

1. Tap the Photos button to bring up the Hosts popover (3.20).

2. Tap the Import button (the down-facing arrow).

3.20 Getting started in Pixelsync

3.21 Choose an event or album to copy.

3. In the Select Library dialog, tap the name of your Aperture or iPhoto library.

4. Tap the Browse Library button.

5. Locate a project, event, or album to import, and tap its checkmark icon to add it to the import queue (3.21). To preview a picture, tap the name of the library item to view its files, and then tap a filename.

6. Tap the Home button.

7. Tap the Import button to start transferring the photos.

▶ **TIP** Did nothing transfer from Aperture? Pixelsync doesn't generate image previews from raw files, so you need to make sure Aperture is doing that job first. In Aperture's preferences, click the Previews category and make sure "New projects automatically generate previews" is selected.

Review and Rate Photos

With photos loaded into Pixelsync, you can take your iPad anywhere and start reviewing them. To open one of the sets you imported and start assigning star ratings, do the following:

1. Tap the Photos button to view the navigator, displaying libraries stored on the iPad.

2. Open a library in Pixelsync's Light Table by tapping its name (3.22).

3. Tap a thumbnail to open the photo in the detail view.

4. Tap one of the rating dots to assign a rating, or tap the X to reject the photo (3.23).

3.22 Choose a library from the navigator popover.

3.23 Tap a star rating in the detail view to assign it to the current photo. Aperture libraries also include a control to assign color labels in this subpanel.

Rating control

▶ **TIP** After rating a photo, swipe left and right to scan through your photos and assign ratings, or use the thumbnail strip to jump to other images in the library. However, to speed up reviewing, go to Pixelsync's preferences (tap the gear button in the navigator popover) and select the "Scroll to next image after rating" option. You can also opt to display a temporary large star overlay to help you verify you tapped the rating you wanted; select the "Visual feedback after rating" option.

Assign ratings in the Light Table

When you're really in a hurry, you can assign ratings directly in the Light Table. Instead of tapping a photo thumbnail, tap and hold anywhere for a second until the rating subpanel appears. You can then tap thumbnails to select them (which adds a soft outer glow to each) and assign a star rating that applies to them (3.24). Tap and hold to dismiss the subpanel.

3.24 Rate photos in the Light Table.

Declutter the Pixelsync Detail View

Having controls within easy reach is laudable, but sometimes you may wonder if a photo is lurking somewhere behind them. Fortunately, Pixelsync offers several ways to declutter the detail view, while keeping the tools easily accessible.

- Tap once on the image to hide the top toolbar and the thumbnail strip.

- Tap and hold anywhere on the top panel to hide the rating subpanel.

- Tap and hold the bottom panel containing the thumbnail strip to hide the filtering subpanel.

- To hide the keyword list, tap the leftmost button on the filtering subpanel.

Assign Keywords

A list of available keywords appears along the left side of the screen, pulled from iPhoto or Aperture. Assigned tags show up in blue to the right of the keywords panel. To locate and add a tag to a photo, do one of the following:

- Scroll through the list and tap a term.

- Better yet, start typing in the Search field to locate a term (**3.25**). If you have hundreds of keywords, this is the best approach.

- Aperture libraries can include root keywords as well as child terms. When children are available, tap the expansion triangle to the right of the tag name to reveal them (**3.26**).

- If a term isn't listed, type it in the Search field and tap the plus (+) button to create a new keyword. You're then asked to save the keyword, but to add it to the photo you need to locate it again and tap it.

- To add a new child keyword, tap and hold a root keyword in the list. In the dialog that appears, type the name of your term and then tap the Save button.

If you need to remove a keyword you added, tap the X button to the right of the tag name.

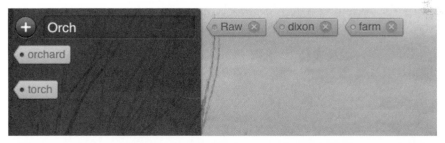

3.25 Type to search for existing keywords.

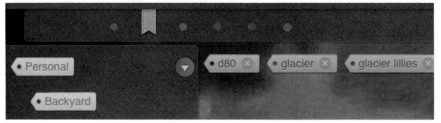

3.26 A child keyword in an Aperture library

View and Edit Metadata

For any photo I plan to share online, I like to include a caption and definitely a title (so the first thing someone sees isn't "IMG_5744"). Pixelsync lets you edit these two values and, in the process, peek at the EXIF data about the current photo:

1. Tap the Info (i) button on the top panel to bring up a popover containing all the nitty-gritty shot data **(3.27)**.

2. Tap one of the Edit buttons to the right of the Version Name or Caption fields to edit them. (Tapping either button brings up the same dialog containing both fields.)

3. Tap outside the popover to dismiss it.

3.27 Metadata for the current photo

Filter Photos

When you want to step back and see which photos have risen to the top of the list, use the Filter Photos feature to show only those images with the ratings you choose.

1. In either the Light Table or the detail view, tap the Filter Photos button in the bottom panel. A list of filter options appears.

2. Tap a rating level to define which photos remain visible (3.28). Tapping "Two stars or better," for example, hides everything but those images ranked two, three, four, or five stars.

 You can also choose to display only unrated photos, only rejected photos, or Aperture images matching one of the available color labels.

3. To go back to viewing everything, tap the Show All button.

▶ **TIP** Combine the filter and sorting tools to display the photos based on star rating. Tap the Rating button on the bottom panel, and then tap Asc (ascending) or Desc (descending) to list photos from highest to lowest or vice versa.

3.28 Select a filtering option.

Sync with Aperture or iPhoto

Back at your computer, it's time to sync the ratings, keywords, and other metadata you've assigned. As long as your iPad and Mac are on the same Wi-Fi network and Pixelsync Helper is running, Pixelsync handles all of the necessary communication. All you have to do is tap the blue Sync button, which appears in the top panel (3.29) as well as in the navigator popover.

3.29 Before (top) and during (bottom) a sync operation

Connection status Last sync Sync button

Rate and Tag Using Editing Apps

I've spent this chapter focused on Photosmith and Pixelsync because they both work with many photos at once. The way I prefer to work, I first review and rate my photos, find the ones that are worth spending more time on, and then bring them into an editing program (on the iPad or on the computer) later. Sometimes it feels as if I can fire off 200 shots just watching dust migrate, so sorting images one at a time just isn't practical.

However, if you're under the gun to process a few shots and share them with an editor or with friends online, running them through Photosmith is overkill. That's why some editing apps now offer the ability to edit various metadata and save that information to the exported image file.

By way of example, I'm using the image editor Photogene, which I cover in more detail in the next chapter. Although the app contains some metadata support, the pro version adds star ratings and the ability to create IPTC sets that you can apply, which allows you to avoid the drudgery of entering the same information repeatedly.

Rate Photos

Photogene (in its pro mode) offers two methods for assigning star ratings:

- While you're viewing photos in their albums, tap and hold a photo until an options bar appears, and then choose View Metadata.

- Open and edit a photo in Photogene's editing environment, and tap the Metadata button.

Tap the General heading in the popover that appears, and then select a star rating (3.30).

3.30 Assign a star rating in Photogene.

Add IPTC Information

Much of the IPTC information that gets embedded with the photo is specific to the shot. In the Metadata popover, tap to edit any of the text fields (3.31).

However, the core data about *you* presumably stays the same, in which case you'll want to create IPTC defaults and sets that you can easily copy and paste to new photos.

Create and use IPTC sets

The advantage to creating sets is that you might want most of the same information (such as contact info) but need something about it tailored for specific uses. In my case, I shoot with two cameras: a Nikon D90 and a Canon PowerShot G12. So, I've set up separate IPTC sets that are nearly identical except for the camera-specific information.

1. In the Metadata popover, tap the IPTC heading and then tap the IPTC Sets button.

2. Tap the plus (+) button to create a new set. Tap the name of the new set to reveal its information fields.

3.32 Make sure Preserve IPTC is turned on.

3. Enter the relevant information in the IPTC fields. When you're done, tap the IPTC Sets button in the popover's menu bar.

The next time you need to quickly add metadata from one of your sets to a photo, tap the Metadata button, tap IPTC Sets, and then tap the Use Set button belonging to the set you created.

▶ **TIP** Using the pro version of Photogene, you can also apply IPTC sets to several photos in a batch. After you fill in the values in one photo, scroll to the bottom of the Metadata window and tap the Copy IPTC button. Then, when viewing your library, tap the Select\Collage button. Tap to choose one or more images, and lastly, tap the Paste IPTC button.

Export IPTC Information

When you're ready to export the photo, make sure the IPTC data goes along with it. Tap the Export button and set the Preserve IPTC switch to On (3.32). The information is written into the file that gets exported.

CHAPTER 4

Edit Photos on the iPad

So far, I've focused mostly on moving photos around—importing them into the iPad, organizing them, and getting them onto your computer. And if the iPad were nothing more than a glorified picture frame, that would be fine. But, of course, it's a powerful image editor, too. A rich array of apps can manipulate pixels in all sorts of ways: apply premade filters to simulate other cameras or eras, correct color and tone, retouch to fix blemishes and other oddities, and much more. Image editing tools on the iPad are especially helpful when you want to share photos soon after importing them, before you're back at a desktop computer.

In this chapter, I focus on common photo adjustments using a handful of representative apps. In practice, I use Snapseed and Photogene interchangeably depending on how I want an image to appear, so I walk through making edits in those apps. If you already have a favorite alternative, you'll find similar controls for accomplishing the tasks I mention. I also include a few specialized apps, such as piRAWnha for editing raw files directly and TouchRetouch HD for removing blemishes or objects from a scene.

Make Photo Adjustments

In an ideal world, every photo I capture would be perfect in-camera, but that's just not the case. (It's a worthy goal to strive for, however—the less work you have to do to an image later, the better.) Most pictures can benefit from a little tinkering in a few areas. Here are the typical areas I focus on when I want to edit an image. Some of these won't apply in all cases, or may not be needed at all, depending on the image.

- **Recompose.** I'm pulling a few concepts under this heading because they each change the boundary of a photo. Cropping is often done to exclude distracting elements at the edges of the frame or to "zoom in" on a subject, but it's also often used to move a subject away from the center of the image for better visual interest.

- **Adjust tone.** Several tools affect a photo's tone: exposure, brightness, contrast, levels, curves, and more, depending on the software. Adjusting tone can usually restore detail to underexposed areas or add definition to a photo that's a bit washed out.

- **Adjust color.** Color usually gets edited when adjusting tone, but color-specific adjustments exist that can help photos. Changing the white balance (color temperature) can remove color casts or bring warmth to cloudy scenes, while saturation controls boost or reduce overall color intensity. Some apps also offer a vibrance control, which affects saturation but preserves skin tones (no sense kicking up the saturation if the people in your photo end up looking like Oompa Loompas).

- **Make specific fixes.** Some photos need isolated adjustments: fixing red-eye, spot-retouching, sharpening, and the like.

- **Apply creative presets.** Most adjustment apps include preset filters that approximate the looks of other cameras, add borders or "grunge" effects, or evoke aged film stock.

▶ **NOTE** Keep in mind that when you edit a raw photo on the iPad, you're making adjustments to a JPEG preview (or, if you originally shot Raw+JPEG format, the higher-quality JPEG version of the photo). That means you won't get the full advantage of manipulating the raw file, which usually yields better recovery in underexposed or overexposed areas. The exception is if you use an app such as piRAWnha that edits the raw file directly (explained later in this chapter).

Edit Photos in the Photos App

I highlight working in third-party apps because they offer more features, but as of iOS 5, Apple's built-in Photos app also includes a few basic editing tools. Tap a photo to view it full-screen, and then tap the Edit button to reveal the following controls:

- **Crop.** Tap the Crop button to enter the Crop and Straighten editor, and then do the following:

 1. Drag the corner handles or the edges of the overlay to redefine the visible area of the photo.

 2. Drag the middle of the photo to reposition the image within the crop area.

 3. If you want to crop the image to a specific aspect ratio, tap the Constrain button and choose an option in the popover that appears. Further adjustments to the overlay don't adhere to that constraint, though; you need to crop and then constrain again if you want to tweak the border.

 4. To straighten the image, press two fingers against the screen and rotate them left or right, like you're turning a radio dial. (You may need to zoom in first, to provide enough padding for the image to fully fill the crop area.) A faint yellow grid appears to help you align objects in the scene (4.1).

4.1 Grid lines help straighten the photo.

- **Rotate.** If a photo was imported sideways or upside down, tap the Rotate button to turn the entire image 90 degrees counterclockwise.

- **Enhance.** Tap the Enhance button to let the Photos app automatically apply tone and color correction.

- **Red-Eye.** If people or animals have an evil glare about them, tap the Red-Eye button and then tap the affected red eyes to correct them. It's helpful to first zoom in (pinch outward), but the app does a good job of identifying eyes even if you don't tap right in the middle.

When you're finished making edits, tap the Save button. Or, tap Cancel to discard the changes. Even after you've saved the picture, you can always resurrect the original version by tapping the Revert to Original button, followed by the Save button (the latter because you need to save the fact that you removed the edits).

Edit Photos in Snapseed

You wouldn't think a recently developed photo editor would offer much to differentiate itself from others in this field, but Snapseed does it with an innovative interface that makes me often turn to it just because it's great to use. Conceived for touchscreen interaction, Snapseed doesn't try to be Photoshop in its approach to editing photos. Instead, it uses immediately familiar swiping gestures to choose which edits to apply and to control their intensities.

To get started in Snapseed, launch the app, tap the Open Image button, and choose the photo you want to edit from your Photo Library. Once the image is loaded, tap one of the app's correction modules **(4.2)**.

4.2 Snapseed's modules lead to controls specific to their adjustments.

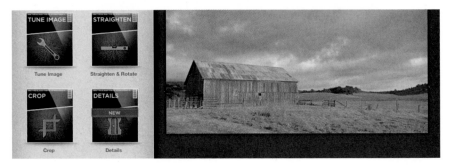

▶ **TIP** In any of the Snapseed modules, tap the Back button to return to the app's main screen without applying any adjustments. Or, while you're working, tap the Preview button to see how the edits will look once applied; in some tools, a Compare button appears instead, so you can toggle quickly back to the version that existed before your edits.

Recompose

To change the visible area of the photo, tap the Crop module and then do the following:

1. Drag the corner handles or edges of the selection rectangle to define the image borders.

2. Tap the Ratio button to constrain alterations to a specific aspect ratio (4.3). Unlike the Photos app, the Ratio control locks the shape, enabling you to refine the borders at that aspect ratio.

 To switch between landscape and portrait orientation for the selection area, tap the Rotate button.

3. Tap the Apply button to accept the cropped area and return to the app's main screen.

4.3 The crop area is constrained to the 16:9 ratio.

If you need to straighten or rotate the image, tap the Straighten & Rotate module and do this:

1. Tap the Rotate Left or Rotate Right button to turn the image in 90-degree increments.

2. Drag left or right on the image to adjust the rotation angle, up to 10 degrees in either direction. (Dragging up or down also works.) Positioning your finger farther away from the center of the image affords more granular adjustments.

3. Tap the Apply button.

Adjust Tone and Color

The Crop and Straighten & Rotate modules use controls similar to other apps for their edits, but most of the other tools work in a central "cross" configuration: Drag up and down to select the type of adjustment you want to make, and then drag left or right to increase or decrease the amount of the adjustment. For example:

1. Tap the Tune Image module.

2. Drag vertically to display the available adjustments and select one, such as Saturation (4.4).

3. Drag horizontally to increase or decrease the amount, indicated at the bottom of the screen (4.5).

4. Repeat steps 2 and 3 to choose other adjustments.

5. Tap Apply to save the edits.

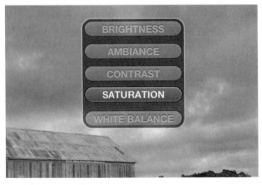

4.4 Choose an adjustment type.

4.5 Drag left or right to specify the amount.

Adjust Specific Areas

Most of Snapseed's tools apply edits to the entire image. When you need to punch up just one area, use the Selective Adjust module. Although it doesn't offer the ability to make precise selections, such as highlighting a certain object in an image, the tool lets you define a feathered, circular area to apply brightness, contrast, and saturation.

1. With an image loaded, tap the Selective Adjust module to open it.

2. Tap the Add button to create an edit point.

3. Tap a location on your image to specify the center of the adjustment.

4. Pinch inward or outward from the point to define the affected area, which shows up as a temporary red mask while you pinch.

5. Drag up or down to choose an adjustment, which is represented on the point by its first letter: B for brightness, C for contrast, and S for saturation.

6. Drag left or right to set the intensity of the adjustment; in addition to the display at the bottom of the screen, the edit point also displays a green border to represent a positive value, or a red border for a negative value, according to the amount (4.6).

7. Repeat as needed to get the look you want, then tap Apply.

▶ **TIP** To make sure you're getting an accurate view of the adjustments you make, turn up the iPad's Brightness setting. Go to the Settings app, tap Brightness & Wallpaper, and drag the Brightness slider all the way to the right. Or, access the control without taking a trip to the Settings app: Double-click the Home button, or swipe up the screen with three fingers, to reveal the list of recent apps. Flick left to right, which displays the Brightness slider as well as music playback controls and the Mute or Screen Lock button. Drag the slider to the right to increase brightness, and then press the Home button to hide the controls.

4.6 To highlight the barn in this photo, I've increased brightness and saturation around the edit point at left (with the blue line indicating the affected area). The edit point at right reduces brightness and increases contrast.

Apply Creative Presets

Half of Snapseed's modules are dedicated to applying creative effects, which follow the same approach as the correction tools. Choose Black & White, Vintage Films, Drama, Grunge, Center Focus, or Tilt & Shift to take a photo in a new direction from the original (the image above was styled with the Drama 2 preset).

▶ **TIP** Most of the presets include a fixed number of styles, but they offer much more variation than you might expect. In Vintage Films, for instance, tap the Texture button and then tap the Properties button to randomly apply texture patterns. Or, in the Grunge module, just drag from left to right to view hundreds of variations in color.

Edit Photos in Photogene

You may already be adept at pushing pixels in Photoshop or Photoshop Elements, in which case you'll find Mobile Pond's Photogene for iPad to be a familiar editing environment. It includes traditional tools such as levels and curves, lets you work with layers and masks, and boasts full-resolution image editing. (Some advanced features require a $7.99 in-app Go-PRO purchase, which is worth it if you're serious about editing photos on the iPad. The regular version, at $2.99, is still quite capable for most editing.)

To get started, browse your Photo Library and tap an image to open it in Photogene's editor. As you work, you can tap the Undo button to step back among your edits; or, at any point, tap the Original button to discard all changes.

Recompose

To recompose a photo using the Crop tool, do the following:

1. Tap the Crop tool to reveal the selection area and a side pane where you can constrain the aspect ratio.

2. Drag the selection handles to define the visible area. You can reposition the selection over the image by dragging the area from the middle using one finger.

3. Tap the Crop button in the pane to apply the crop.

4. To dismiss the Crop interface, tap the Crop button in the toolbar.

For images that are a bit (or a lot) askew, follow these steps:

1. Tap the Rotate button in the toolbar.

2. In the Rotate panel that appears, drag the Angle slider to straighten the image (4.7). Photogene applies the change as soon as you let go of the slider.

You can also rotate the image by quarter turns or flip the image horizontally or vertically.

▶ **TIP** To reset any adjustment slider's value to its default, double-tap it.

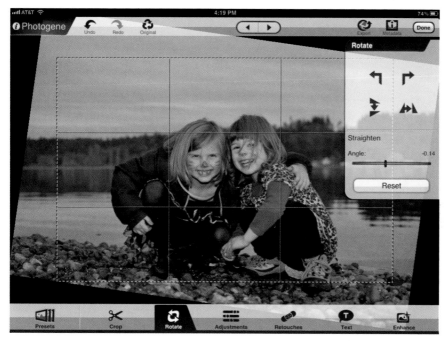

Adjust Tone and Color

Photogene includes several tools for adjusting brightness, contrast, and color, each of which have their own strengths. The Brightness controls, for example, can brighten or darken an image or pull detail out of shadows and highlights. Or, you may prefer to adjust white and black levels using the histogram, or adjust curves to manipulate separate red, green, or blue channels.

▶ **TIP** While you're editing, tap and hold the A/B icon to the right of the side panel's title to view the uncorrected version of the image.

Adjust brightness and contrast

I often shoot with exposure compensation set to –1 (or maybe a third of a stop) because it results in slightly more saturated colors and, more importantly, reduces the chance that portions of my image will end up blown-out to all white. Camera sensors, especially when shooting in raw mode,

capture a lot of detail in shadows that might not immediately be apparent. Pixels that are blown out, however, rarely offer any usable image data.

The easiest method is to manipulate the sliders in the Brightness section of the Adjustments panel:

1. Tap the Adjustments button to reveal the panel.

2. Drag the Exposure slider to increase or decrease the photo's overall brightness (4.8).

3. Drag the Contrast slider to enhance the distinction between light and dark pixels.

4. To illuminate pockets of darkness, drag the Lighten Shadows slider; this control also affects the full image, but not to the extreme that the Exposure slider does. Similarly, use the Darken Highlights slider to try to recover overly bright areas.

▶ **TIP** I almost always tap the Auto button to see what the software suggests for a fix. And just as often, I follow that by either tweaking the sliders or tapping Reset and starting over. But viewing the automatic settings helps me determine which areas of the image need work.

4.8 Adjusting exposure in Photogene's Brightness panel

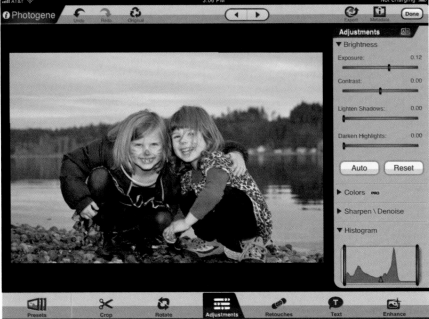

THE iPAD FOR PHOTOGRAPHERS

If you're more familiar with adjusting levels in desktop software, scroll down to the Histogram section, where you can drag the left vertical bar to set the clipping point of black pixels (making the image darker) or drag the right bar to specify highlight clipping (making the image brighter). The triangle in the middle darkens or brightens the image's midtones.

▶ **TIP** Tap once on the image to hide all of Photogene's panels and controls for an uncluttered view of the photo. Tap again to make the controls visible.

Some people prefer to adjust exposure using curves, a feature available in the pro version of Photogene.

1. In the Adjustments panel, tap the Show button in the Curves section. The interface appears over the top of the image (4.9).

2. To increase brightness, tap the control point in the middle of the grid and drag it up and to the left. Dragging it toward the lower-right area of the grid decreases the exposure.

3. Tap anywhere on the curve to add a new control point, which you can use to further adjust the tones. For example, adding another point toward the lower area of the curve lets me apply contrast (by compressing the dark values) while retaining the increase in exposure I applied in the previous step (4.10).

4. Tap the Hide button in the Adjustments panel when you're done.

4.9 The Curves interface

4.10 Adding a control point

Adjust color cast

Does your photo look a little green? The adjustment tools can compensate for color shifts as well as exposure values:

- In the Adjustments panel, drag the RGB sliders to increase or decrease the red, green, or blue offsets.

- If you've purchased the pro version of Photogene, bring up the Curves editor and then tap one of the colored tabs to the left to edit just those channels.

- ▶ **TIP** Tap and hold anywhere on the image to bring up a Copy Edits command, which notes the adjustments you've made. Then, in another image, tap and hold to view a bar of options, and choose Paste Edits to apply them to that image.

Adjust white balance

If your camera misinterpreted the existing light as being too cool or warm, you can specify a new value for white balance (also called color temperature). Living in Seattle, I often do this to add warmth to photos taken under gray skies, but cameras can be thrown off by fluorescent or incandescent light bulbs as well.

1. Tap the Adjustments button, and scroll down to the Colors section of the Adjustments panel.

2. Drag the Color Temperature slider left (cooler) or right (warmer).

In Photogene's pro version, you can set the white balance by identifying an area that is white, black, or neutral:

1. Scroll down to the Colors section of the Adjustments panel and tap the eyedropper icon.

2. Tap and hold on your image to bring up a zoomed-in loupe, and then drag to locate a neutral color (4.11).

3. Lift your finger; Photogene picks a Color Temperature value based on your selection.

Adjust saturation and vibrance

To boost or pull back the color in your image, drag the Saturation slider. However, to retain skin tone, the Vibrance slider might give better results.

Apply Selective Edits

You won't always want to apply adjustments to the entire image. Photogene's Retouches category of tools includes a healing brush but also masking overlays that let you paint areas to be adjusted. For example, use the Dodge tool to brighten an area, or enhance the depth of a photo by applying the Blur tool to its background. The pro version of the software lets you adjust exposure, saturation, contrast, color temperature, and RGB offset values in areas you paint.

1. Tap the Retouches button in the toolbar.

2. Tap one of the Masking Overlays tools.

3. Set the diameter of the brush by tapping the Brush button and specifying Radius and Feather amounts using the sliders provided. Tap the button again to dismiss the popover.

4. Begin painting the edit onto the photo by dragging (4.12). To erase an area you've painted, tap the Erase button; or, easier, tap once on the photo to switch between the Paint and Erase tools.

 Normally, you see the effect that painting produces as you work. However, you can also tap the Contour button to view the edit area in translucent red.

5. Tap the Done button at the bottom of the panel when you're finished.

4.12 Apply edits to selective areas. In this case I've inverted the Grayscale tool so I can erase the balloon and reveal its color.

Apply Creative Presets

Photogene offers dozens of presets: Tap the Presets button and choose among several categories (Colors, B&W, Vintage, Frames, and Fun). Then, tap a preset to apply it.

What's more interesting is the ability to save your own presets. For example, if you find yourself applying the same amount of vibrance and sharpening to your images, create a preset. After setting those options on a photo, tap the Presets button, tap My Presets, and then tap Save.

Edit Raw Files Directly

For most of this book, I've referred to this section as an interesting asterisk. In general, the iPad ignores raw files: You can import them, but editing and sharing occurs on their JPEG previews or on the JPEGs that were recorded if you shot Raw+JPEG originals. iOS accepts raw files, but it doesn't support the myriad translators that are required to work with them directly. (I'm sure that's a deliberate design decision on Apple's part. Keeping up with camera manufacturers' proprietary raw formats happens slowly on the Mac because the decoders operate at the system level.)

However, working with raw files is really just a computational hurdle. If Apple won't provide the foundation for manipulating raw files, other developers are happy to step in. Two apps that do are piRAWnha and PhotoRaw.

These apps can act as preprocessors for a photo—similar to the way the Adobe Camera Raw plug-in works in Photoshop. If you're working with a dark image, for example, running it through piRAWnha first may tease out detail that another editor might overlook. Then, after exporting the file (as a JPEG), use Snapseed or Photogene to perform additional edits. Or, if your images need only minor tonal or color saturation adjustments, they may benefit just from a pass through a raw editor without any further processing.

To be up front, editing raw files on the iPad isn't yet ideal. Expect editing to take a while, even just to make what would be a trivial adjustment on a computer—although the iPad's processor has lots of oomph, the amount of working memory (256 MB on the original iPad, 512 MB on the iPad 2) limits how much data can be processed at a time. I anticipate this capability will improve as software and hardware advances.

I prefer the interface of piRAWnha, so that's what I'll use as the example:

1. When you open the app, tap an album from your Photo Library.

2. Tap the image you want to edit.

3. Use the sliders at right for each control to edit the photo's attributes. As you drag, a preview appears at the lower-right corner (4.13).

▶ **TIP** Many sliders don't offer much horizontal space to make fine adjustments, but there is a way to choose specific increments: Tap and hold a control to display a popover.

Some adjustments are tailored to the raw format the software is editing. For example, tapping the White Balance button offers a Camera-Specific option that reveals the settings on my Nikon D90 (written as the specification dictates, such as "Incandescent" and "SodiumVaporFluorescent").

4. Once you've specified all of your adjustments, they aren't immediately applied. Instead, tap the Add to Queue button.

5. Tap the Load Photo button to work on another photo. Or, tap the Export Queue button to process the images waiting in the queue. When finished, the edited JPEG files appear in your Camera Roll.

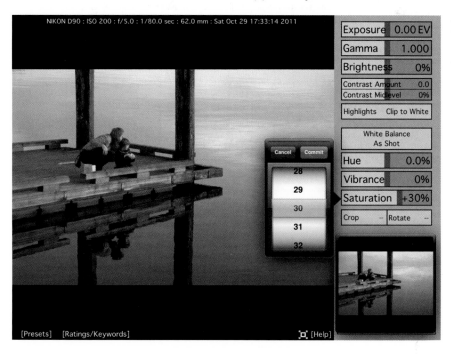

4.13 piRAWnha's editing interface

Retouch Photos

Photo retouching is an area where desktop titans like Photoshop still rule from on high, but some adjustments are possible on the iPad. Although you're not likely to touch up a portfolio of fashion shots using the iPad alone, it's possible you'll want to fix minor blemishes in photos that you plan to share directly from the iPad.

Photogene

Photogene's Heal tool fixes errors by cloning related areas of a photo. I recommend zooming the image to make it easier to control how the edits are applied.

1. Tap the Retouches button to view the Retouches panel.

2. Tap the Heal button.

3. Double-tap the area you'd like to fix (4.14). Photogene adds a pair of retouch circles: One covers the area you selected (and is marked with a gray X), and the other copies a nearby area.

4. Drag the blue anchor points to resize the retouch circle.

5. Drag the center of either retouch circle to reposition it (4.15).

6. Tap the Done button in the Retouches panel to finish.

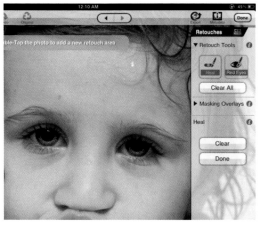

4.14 Identify an area to fix (the scratch above her eye).

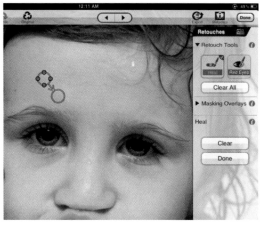

4.15 Clone pixels from a nearby area to retouch the spot.

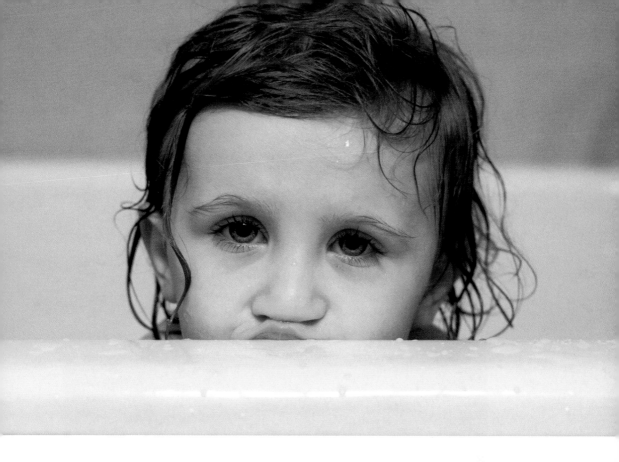

TouchRetouch HD

Photogene (and other approaches) samples nearby pixels to apply fixes. Another way to tackle the problem is to make software fill in pixels computationally based on the surrounding area. In Photoshop CS5 and later, Adobe calls this "content-aware" healing. In the app TouchRetouch HD, AdvaSoft uses this type of technology to achieve similar results. It can be especially useful when you need to remove unwanted people or objects from a scene.

In the app, open a photo you'd like to edit, and then do the following:

1. In the dialog that first appears, pick the resolution at which you'd like to work. Choosing a higher resolution takes longer to process, so if you don't need the original's full dimensions, select one of the smaller ones.

2. Double-tap the image to zoom to 100%, which makes it easier to define the area to be edited.

3. Mark an object to remove by selecting the Lasso tool and drawing around it or by selecting the Brush tool and painting over it (4.16). Use the Eraser tool to refine the edges. You don't need to be too specific about defining the area accurately.

4. When you've identified the area, tap the Go button. The object you selected disappears.

5. If the end result isn't quite to your liking, try painting over the area again. Or, use the Clone tool to pinpoint a similar source area and then paint over the area you're trying to fix.

6. Tap the Save button to save a copy of the photo to your Photo Library, to attach it to an outgoing email, or to share it via Facebook, Flickr, Picasa, or Twitter.

4.16 As you paint an area to be fixed (in this case, a toy in the background), a preview window appears so you can see the area (which is often obscured by your finger).

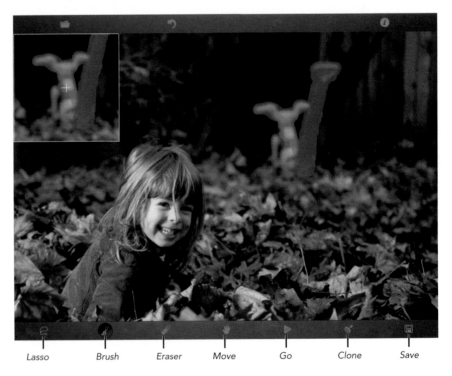

Lasso Brush Eraser Move Go Clone Save

CHAPTER 5

Edit Video on the iPad

I admit, I look at the title of this chapter and am a little amazed at its implications. Editing video was once something you could do only with a massively expensive infrastructure of equipment. Even as computing power increased (and the cost of software decreased), one still expected to need a high-powered desktop or laptop computer to edit video.

And now here we are, editing high-definition video in real time on a tablet computer. Oh, and using an app that costs $4.99. Granted, the iPad is no slouch in the processor department (though it still offers a comparatively small amount of RAM, which is why iMovie doesn't run on the first-generation iPad), and iMovie for iOS doesn't give you all the features of a desktop video editor.

But still: editing HD video on a tablet. The future is fun.

Work with Projects in iMovie for iOS

Every movie you edit is its own iMovie project, accessible from the neon-lit opening screen. To get you started quickly, however, iMovie jumps right into the editing environment after you create a new project. You can return later to grace the project with a name.

At the main screen, tap the New Project button. iMovie takes you to the editing environment (5.1), which works in either the horizontal or portrait orientation.

▶ **NOTE** Although I'm focusing on iMovie in this chapter, it's not the only video editor available for the iPad. Shortly before this book went to press, Avid released Avid Studio for iPad, which looks to be a serious contender. It's also worth checking out ReelDirector, a video editor that predates iMovie. And I'm sure more video editing apps are on the way.

5.1 The iPad editing environment in landscape orientation.

When viewed in portrait orientation, the Media Library is hidden and accessible as a popover window.

Media Library Viewer Project Settings window

Timeline Playhead

To give your project a name, do the following:

1. Make any edit, such as adding a clip to the timeline.
2. Tap the My Projects button to return to the opening screen.
3. Tap the title in the marquee to make it editable.
4. Enter a new title, and then tap the Done button on the virtual keyboard.

▶ **TIP** If you create a project and then immediately return to the opening screen, iMovie discards the new project because it has no content.

Choose a Theme

Every movie must have a theme, even if you don't plan to use theme elements. New projects adopt the Modern theme, but you won't see evidence of it unless you specifically choose a themed transition or add a title to a clip. You can change a project's theme at any time. Any themed assets in the movie automatically switch to the chosen theme (which also means you can't mix and match elements from different themes in the same project).

1. Tap the Project Settings button.
2. In the Project Settings window, drag the theme thumbnails left or right to highlight the theme you want to use.
3. Tap outside the window to apply the setting.

Apply a Fade In or Fade Out to the Movie

Instead of starting with the first frame of the first clip, you may want to begin your movie with a fade in from black. The Project Settings window includes a single-switch option for adding fades to the start and end of a project.

1. Tap the Project Settings button to open the Project Settings window.
2. Tap the switch next to "Fade in from black" or "Fade out to black" (or both) to change the setting from Off to On.
3. Tap outside the window to apply the setting.

Open an Existing Project

iMovie keeps track of your saved projects on the opening screen, like you're choosing a video at a stylish multiplex.

1. Tap the My Projects button to return to the main screen.
2. Swipe the project icons until the one you want is highlighted.
3. Tap the icon to open the project.

Add Video to a Project

iMovie for iOS is picky about the video it uses. Basically, if the video came from an iPad, iPhone, or iPod touch, you're golden. (I've also had success with footage from my old Flip MinoHD.) If you want to bring in video you've shot using other cameras, you need to first convert it on your computer. That said, there are several ways to get video into iMovie.

Capture Video Directly

Using the cameras on the iPad, you can record video directly into your iMovie timeline. With a project open, do the following:

1. Tap the Camera button.
2. Set the mode switch to video.
3. Tap the Record button to begin capturing the footage.
4. Tap the Record button again to stop recording.
5. Press the Play button that appears to review your footage. If the clip is acceptable, tap the Use button. The clip appears in the Video browser and at the point in your movie where the playhead was positioned.

 If the clip isn't what you want, tap the Retake button and shoot again.

I've expressed my reservations elsewhere about the quality of the cameras in the iPad 2, but it's important to detail this approach because iMovie treats video differently depending on whether it was captured or imported. Namely: Video shot by the device stays with the project in which it was

captured. It isn't automatically added to the Camera Roll, which is where the iOS stores photos and videos that were shot by the Camera app or imported using the iPad Camera Connection Kit. If you create a new project, that clip you shot won't appear at all.

However, there is a workaround: Move a clip to the Camera Roll by tapping the Edit button and then tapping the Move button.

Import from an iPhone or iPod touch

I'm far more likely to shoot video using my iPhone than my iPad, but even though iMovie also runs on the phone, I prefer to edit on the iPad's larger screen. Following the same procedure for importing photos described in Chapter 1, import media into the iPad's Camera Roll from an iPhone or iPod touch using the iPad Camera Connection Kit.

Add Clips from the Media Library

With a library of clips to work from, it's easy to add clips to your project's timeline.

1. Scroll to the position in the timeline where you want the clip to appear. (This doesn't apply if no clips are in the timeline yet.)

2. If you're holding the iPad in its portrait orientation, tap the Media Library button. (If editing on the iPad in landscape orientation, the Media Library appears in the upper-left corner.)

3. To preview the contents of a clip, drag your finger across it.

4. Tap once on a clip to reveal its selection handles.

5. Drag the handles to define the portion of the clip you want to add (5.2).

6. Tap the clip again to add it to the timeline.

5.2 Select a portion of a video clip to add.

Edit Video

Editing video in iMovie requires just a few core concepts, which you'll quickly adopt as second nature.

Play and Skim Video

The timeline in iMovie for iOS runs left to right across the bottom of the screen. Tap the Play button to preview the movie in real time in the Viewer.

To skim the timeline, swipe left or right. The playhead remains in the middle of the screen, so instead of positioning the playhead on the video, you're actually moving the video clips under the playhead (5.3).

▶ **TIP** When the movie expands beyond the edges of the screen, tap and hold the upper-left edge of the timeline to quickly jump to the beginning of the movie. Hold the upper-right edge to jump to the end.

5.3 The Viewer shows the current frame under the playhead.

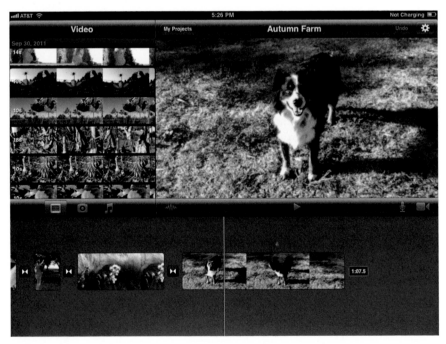

Edit Clips

After adding footage to the timeline, you'll find yourself moving, trimming, splitting, and deleting clips to cut out unwanted sections and create good timing.

Move a clip on the timeline

1. Tap and hold the clip you want to move. It lifts out of the timeline as a small thumbnail (5.4).

2. Without lifting your finger from the screen, drag the clip to a new location in the timeline.

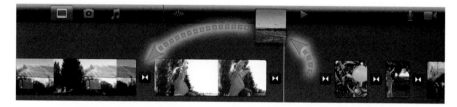

5.4 Move a clip in the timeline.

Trim a clip

1. Tap a clip once to reveal its selection handles.

2. Drag a handle to shorten or lengthen a clip (5.5).

5.5 Trim a clip.

Split a clip

A clip can be added only before or after an existing clip; you can't insert a new clip in the middle of an existing clip. To do that, you must first split the clip in the timeline.

1. Position the clip so the playhead is at the point where you want to split it.

2. Tap the clip to select it.

3. Slide one finger down the playhead from the top of the clip to the bottom (5.6). The clip is split into two, with a transition added between them. (The transition, however, is set to None, so there's no break between clips when you play the video. See "Edit Transitions," later in the chapter.)

5.6 Split a clip.

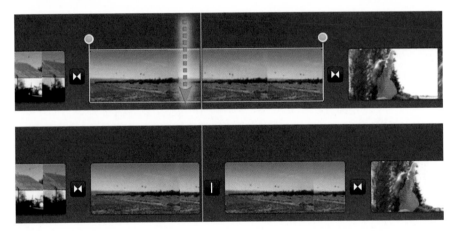

Delete a clip

Drag a clip from the timeline to the Viewer until you see a small cloud icon appear (5.7). When you lift your finger from the screen, the clip disappears in a puff of smoke.

5.7 Give a clip the Keyser Söze treatment.

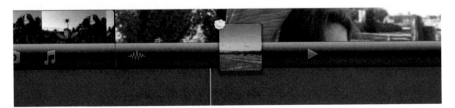

Use the Precision Editor

1. Tap a transition icon to select it, and then tap the double-triangle icon to display the Precision Editor (5.8). Or, pinch outward vertically on a transition.

2. Do any of the following to adjust the edit point:

 • Drag the transition itself to reposition the edit point without changing the duration of the surrounding clips.

 • Drag the top handle to change the end point of the previous clip without adjusting the next clip.

 • Drag the bottom handle to change the start point of the next clip without adjusting the previous clip.

3. Tap the triangle icons, or pinch two fingers together, to close the Precision Editor.

▶ **NOTE** It's not possible to adjust the duration of the transition from within the Precision Editor. For that, you need to edit the transition itself.

▶ **TIP** To view more thumbnails in the timeline, pinch outward horizontally with two fingers to expand the clips; pinch inward to compress the sizes of the clips.

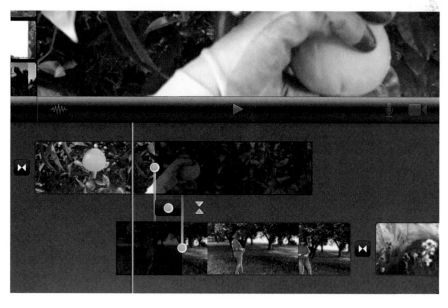

5.8 Use the Precision Editor to more accurately set where adjoining clips begin and end.

Edit Transitions

Whether you like it or not, iMovie automatically adds transitions between every clip. Now, before your imagination fills with endless cross dissolves, note that it's possible to have a transition that doesn't do anything at all—it's there so you can tap it and change its settings.

1. Double-tap a transition icon to reveal the Transition Settings window (5.9).

2. At the left side of the window, scroll to choose the type of transition: None (creating an abrupt jump cut between the clips on either side), Cross Dissolve, or Theme.

 The appearance of the latter depends on which theme you chose for your project. To change the theme, tap the Project Settings button and highlight a new one, as described earlier in the chapter.

3. At the right side of the window, scroll to choose one of the four preset durations for the transition.

4. To apply the changes, tap outside the window to dismiss it.

5.9 Choosing a transition style and duration

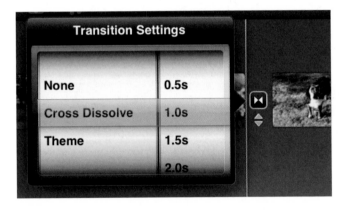

Add a Title

Any clip can have a title, which is an attribute of the clip, not something added separately.

1. Double-tap a clip to view the Clip Settings window (5.10).

2. Tap the Title Style button; the default style is None.

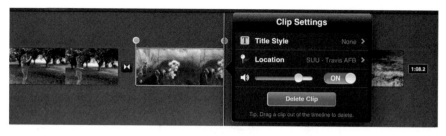

3. Choose a title style: Opening, Middle, or Ending. The styles depend on the project's theme and are designed for common spots in your movie. For example, Opening is good for titles at the start of a movie and can occupy the entire screen, while Middle typically runs a title at the bottom of the screen without obscuring your video. Of course, you can choose whichever style you want at any point in your movie.

4. Tap the text field in the Viewer, and enter your title text (5.11).

5. Tap Done in the virtual keyboard to stop editing the title.

Add a title to just a portion of a clip

A title spans the entire length of a clip—even if the clip is several minutes long. If you want the title to appear on just a portion, such as the first few seconds, do the following:

1. Position the playhead in the clip where you want the title to end.

2. Split the clip.

3. Double-click the portion you want, and add a title to it.

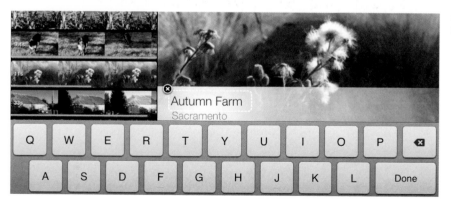

5.11 Entering text in a theme title

Specify a Location

The iPad 2 (and later), iPhone, and iPod touch can all embed location data in the photos and video they capture, thanks to their built-in assisted-GPS technologies. iMovie reads that data, too, and gives you the option of using it in titles and, creatively, a few themes.

1. Double-tap a clip to bring up the Clip Settings window.

2. Tap the Location button.

3. If location information was saved with the clip, it appears in the Location window (5.12). To change the location, do one of the following:

 * To use your current location, tap the crosshairs button.

 * To find a location, tap the Other button to search iMovie's database of locations. Tap the closest match to use it.

4. You can also change the label to something more specific, like a neighborhood or restaurant name. Tap the label and enter new text; it won't change the underlying location data. For example, the Travel theme adds a location marker to a map in its Opening title; the marker stays in place, but its label changes (5.13).

5. To exit the Clip Settings window, tap outside it.

5.12 Location settings

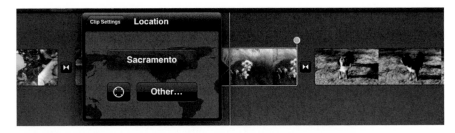

5.13 A custom label applied to the location data

5.14 Use the Location line as a subhead.

► **TIP** In most themes, the location appears as a subhead below the title. If you don't want to announce the location, why not put that text to good use? In the Location window, enter any text you wish to display, even if it has nothing to do with location (**5.14**).

► **TIP** As you're working on editing your movie, you can tap the Undo button to reverse the last action. But what if you tap Undo a few too many times? Tap and hold the Undo button, which reveals a Redo button.

Add and Edit Photos

Predictably, iMovie for iOS can import photos as well as video, and even manages to apply the Ken Burns effect to them. In fact, every photo gets the Ken Burns treatment, without an easy way to keep an imported photo from moving.

Photos you've shot using the device or that were synced from your computer can be brought into your iMovie project. As with video, if you captured photos from within iMovie, those images are restricted to the project that was active when you did the shooting.

To add photos to your project, do the following:

1. Position the playhead in the timeline where you want a new photo to appear.

2. Go to the Media Library and tap the Photos button to view available photo albums.

3. Tap an album name to view its photos (5.15).

4. To preview a photo, tap and hold its thumbnail. On the iPad in landscape orientation, the preview appears in the Viewer.

5. Tap the photo thumbnail once to add it to the timeline.

Edit the Ken Burns Effect

The Ken Burns effect is based on the position of the frame at the beginning and end of the clip. iMovie determines how best to make the camera move from one state to the other.

1. In the timeline, tap a photo you've imported to select it.

2. Tap the Start button to move the playhead to the first frame of the clip (5.16).

5.16 Editing the Ken Burns effect

3. Position the starting frame the way you wish: Pinch inward or outward to zoom in on, or out of, the frame.

4. Tap the End button to move the playhead to the last frame of the clip.

5. Adjust the image to the way you want it to appear at the end of the sequence.

6. Tap Done. iMovie builds the animation between the Start and End frames automatically as the movie plays.

Disable the Ken Burns effect

Unfortunately, there's no easy control to turn off the Ken Burns effect and just display a static photo. However, a workaround is possible.

1. Tap the Start button.

2. Pinch the image onscreen so you can see all of its edges (zoomed out), and then release it—iMovie snaps it back into place with a minimal amount of zoom applied.

3. Tap the End button and repeat step 2 to let iMovie snap it into place.

4. Tap Done to stop editing the photo.

Edit Audio

One area where iMovie for iOS sacrifices features for mobility is in editing audio. You can adjust the volume level for an entire clip, but not specific levels within the clip; it's also not possible to detach audio from a video clip. Still, that leaves plenty of functionality, especially now that you can add multiple background music clips, include up to three additional sound effects at a time, and record voiceovers. Viewing audio waveforms on tracks is extremely helpful. Tap the Audio Waveforms button to make them visible.

Change a Clip's Volume Level

So you don't have multiple audio sources fighting for attention, you can adjust the volume level for any clip, or mute it entirely.

1. Double-tap a clip in the timeline to display the Clip Settings window.

2. Drag the volume slider to increase or decrease the overall level (5.17). To mute, tap the On/Off switch so it's set to Off.

▶ **NOTE** Whenever a video clip with audio appears over a background song, the song is automatically ducked (made softer). Unfortunately, iMovie offers no controls for specifying the amount of ducking to apply.

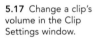

5.17 Change a clip's volume in the Clip Settings window.

Audio Waveforms button

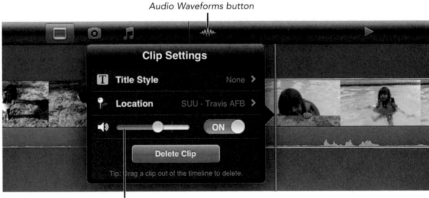

Volume slider

Add Background Music

iMovie can include background music, designed for the current theme, that loops in the background. Or, you can add your own audio tracks (with a few limitations). What's unique about iMovie's approach (and this is mirrored in iMovie on the Mac) is that a background music track is a separate type of audio track that operates a bit differently than iMovie's other audio tracks and sound effects. A background song always starts at the beginning of the movie; it can't be pinned to a specific location in the movie.

Add automatic theme music

1. Tap the Project Settings button.

2. Tap the Theme Music switch so it's set to On. (The Loop Background Music option is automatically selected.)

3. Tap outside the Project Settings window to apply the setting.

Add a background music clip

1. Go to the Media Library and tap the Audio button.

2. Choose an audio source (5.18). In addition to iMovie's theme music selections, the Audio window gives you access to your iTunes music library, sorted by playlists, albums, artists, or songs.

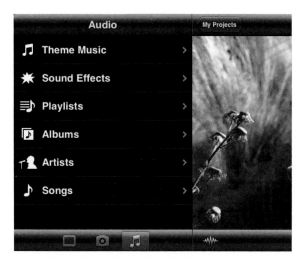

5.18 Audio window

3. Tap the name of a song to add it to your project. It appears as a green track behind the video clips in the timeline (5.19).

 ▶ **TIP** Music written for each theme is available to add to any project, not just to movies with those themes. In the Audio window, tap Theme Music and choose any song you wish.

5.19 A background song added to the timeline

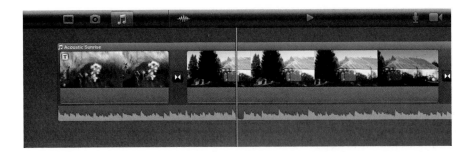

4. To add multiple background songs that play one after another, go to the Project Settings window and deselect the Loop Background Music option. You can then add more audio clips. If you don't change that project setting, iMovie replaces any background song when you add a new one.

 ▶ **NOTE** iMovie does not import any music encumbered with Apple's Fair-Play DRM scheme; those tracks appear in the song list, but in gray with "(Protected)" before their names. Apple abandoned DRM for music tracks a while ago, but you may still have tracks in your iTunes library from before the switch. If you still want to use a specific song, go to iTunes on your computer, click iTunes Store in the sidebar, and then click the iTunes Plus link under Quick Links. That gives you the option to upgrade protected songs (for a fee of $0.30 per song or 30 percent of an album's current price) to the DRM-free iTunes Plus format.

 ▶ **TIP** iMovie considers any audio file less than one minute in length to be a sound effect, and won't add it as a background song.

Aside from the fact that a background song can't be repositioned in the timeline, you can edit it like most clips. Tap to select it and then adjust its duration using the selection handles, or double-tap it to adjust the clip's overall volume. One downside, however, is that you can't apply a fade to an audio clip, so if you shorten the clip, the audio ends abruptly.

Add a Sound Effect

When you want to add a little punch to your audio, consider throwing in a sound effect. Up to three sound effect clips can appear in a section.

1. Position the playhead at the section where you want a sound effect to start.

2. In the Media Library, tap the Audio button.

3. Tap the Sound Effects button to view a list of available effects.

4. Tap the effect you want to use to add it to the timeline (5.20).

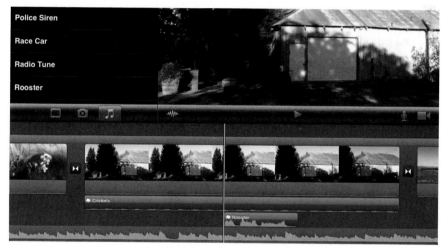

5.20 Sound effects appear on tracks below the video.

▶ **TIP** iMovie's automatic assumption that any audio clip less than one minute in length is a sound effect is an annoyance when you want to use a short song to open your movie. But it's also an advantage: You can add any music file that's under one minute—whether its content is a sound effect or not—as a sound effect clip.

▶ **TIP** Using iMovie's audio recording feature, you can record sound effects while you're shooting or anywhere else. See "Add a Voiceover," on the next page.

Add a Voiceover

Most of the time, your videos can speak for themselves. On occasion, though, you may want to provide narration or a commentary track that plays over the footage. iMovie's audio import feature lets you record your voice (or any sound, for that matter) into the timeline.

1. Position the playhead in your movie where you want to begin recording audio.

2. Tap the Record button to bring up the Ready to Record window.

3. When you're ready to start capturing audio, tap the Record button in the window. iMovie counts down from 3 to 1 and begins recording (5.21).

4. Tap the Stop button to end recording. The recorded clip appears as a purple audio clip below the video in the timeline.

5. Choose what to do with the recorded clip: Tap Review to listen to it; tap Retake to record again; tap Discard to delete the recording; or tap Accept to keep it in your project.

Feel free to record multiple takes, but keep in mind that you can have only three audio tracks in one spot at a time. Also, mute the other takes before you record a new one.

▶ **TIP** To capture better-quality audio, consider using a microphone instead of relying on the device's built-in mic. That can be the microphone on the earbuds that come with the iPhone or even, when connected to the iPad using the iPad Camera Connection Kit, a professional microphone or USB headset.

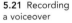

5.21 Recording a voiceover

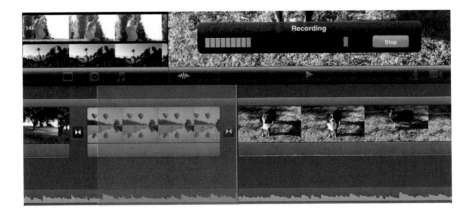

Share Projects

iMovie for iOS is designed to easily turn footage into a movie, but it's also intended to take your video and share it with the world (5.22). That could mean saving the finished movie to the Camera Roll for later viewing or for importing into iTunes on your computer. You can also post it directly to YouTube, Facebook, Vimeo, or CNN iReport (but those options are straightforward, so I don't cover them here).

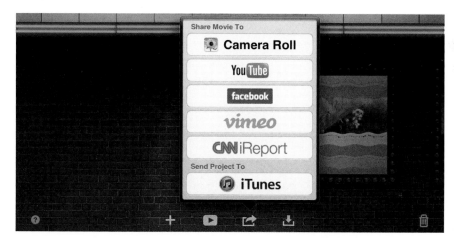

5.22 iMovie's sharing options

Share to the Camera Roll

When you share your project to the Camera Roll, a final version of the movie is created and made available for you to not only watch, but also access from other apps that can read your photo and video library.

1. Tap the My Projects button to return to the opening screen.

2. With the project you want to share highlighted, tap the Share button.

3. Tap the Camera Roll button.

4. In the dialog that appears, choose a resolution to export: Medium - 360p, Large - 540p, HD - 720p, or HD - 1080p. iMovie creates the finished movie and saves it to the Camera Roll.

5. To view the movie there, open the Photos app, locate the movie at the bottom of the Photos list, and tap the Play button.

Send the Project to Another Device via iTunes

This method of sharing an iMovie project is, quite frankly, a weird work-around, but it has its uses. You can export the project itself—not just a rendered version of the movie—for backing up to your Mac, sending to another iOS device for editing, or importing into iMovie on the Mac. It is, however, a fairly counterintuitive procedure.

Export a project to iTunes

1. At the My Projects screen, highlight the project you wish to export and tap the Share button.

2. Tap the Send Project to iTunes button. iMovie packages all the data and resources (including video clips and audio files) and then informs you when the export is complete.

3. Connect your iPad to your computer.

4. Open iTunes and select the device in the sidebar.

5. Click the Apps button at the top of the screen and scroll down to the File Sharing section.

6. Select iMovie in the Apps column.

7. Select the project you exported (5.23) and click the Save To button. Specify a location, such as the Desktop.

5.23 The exported project in iTunes

Import the project into iMovie on another iOS device

1. Connect the other device to iTunes and select it in the sidebar.

2. Go to the Apps screen, scroll down to the File Sharing section, and select iMovie in the Apps column.

3. Click the Add button and locate the project file you exported in the previous exercise. Or, drag the project from the Finder to the iMovie Documents column. (You don't need to sync the device to copy the file; it's added directly.)

4. Open iMovie on the device.

5. Although the project now exists on the device, iMovie doesn't yet know about it. Go to the My Projects screen and tap the Import button.

6. In the dialog that appears, tap the name of the project to import it. It appears among your other projects (5.24).

See? Only 13 steps to move a project from one device to another!

▶ **TIP** This method is also a way to duplicate a project—for example, if you want to save what you've done but try an editing experiment. After sharing to iTunes, tap the Import button to bring a copy back in; it will have a slightly different name.

5.24 The project as it appears on an iPhone after being copied through iTunes

Build an iPad Portfolio

The desire to showcase your photos may have been your impetus to buy an iPad in the first place. The benefits are compelling: You can show off your work on the large screen, where the backlight makes the photos pop. You don't need to create a printed portfolio, which can involve considerable cost and requires lugging it around whenever you're meeting with a prospective client. And you or your client can zoom in to examine photos in detail.

An iPad portfolio also extends your reach beyond an initial meeting. Email a photo to a client directly from the iPad so they have something more than a business card or a print to remember you by. And since you're likely to have your iPad with you at other times, impromptu portfolio viewings are possible wherever you are—airplanes, lunches, or even just around the coffee table with family members.

5 Steps to Create a Great Portfolio

Before getting into the nuts and bolts (or more accurately, taps and swipes) of building a portfolio, let's look at what makes a portfolio successful. It's easy to throw all your photos onto the iPad and use the Photos app to play a slideshow. What makes a good portfolio stand out is how well it's edited. I doubt there's such a thing as a portfolio that's too small, but many portfolios end up being much too large.

1. **Include only your best work.** I know this should seem obvious, but I find that when I'm picking photos for my portfolio, I often consider one because it's a favorite, not necessarily because it's great. That's an important difference. Always think about how best to impress the person viewing your portfolio.

2. **Demonstrate your range.** Choose photos that show a variety of skills and styles, to better help the client imagine what you're capable of, not just what you've done before.

3. **Tell a story.** Even if your photos are pulled from a variety of situations and styles, your portfolio shouldn't come across as if it had been just thrown together. Start and finish with your best images, and give purpose to everything in between. That can be as literal as starting with images that were shot early in the day and ending with those set at night (6.1), or working through the various stages of a wedding (preparation, ceremony, reception). Or consider working through the color spectrum—black and white images first, building to full-color, high-saturation closing shots.

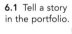

6.1 Tell a story in the portfolio.

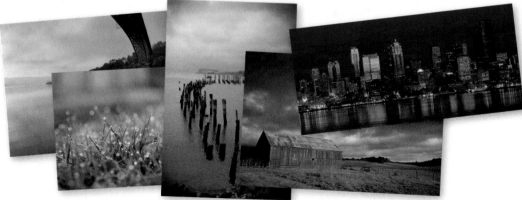

4. **Build multiple portfolios.** If you work in several areas, create portfolios for each, such as for weddings, for landscapes, for portraits, and so on (6.2).

5. **Update the portfolio as needed.** A digital portfolio isn't limited by paper. As you create more great shots, add them to your portfolio to keep it fresh. If necessary, rotate out old images to prevent the portfolio from getting bloated or looking dated.

▶ **TIP** Make sure your iPad portfolio reflects your online portfolio. I can almost guarantee that clients will search for your work online on their own time. Make sure your talents are equally represented there. If you have a personal photo library online, such as at Flickr, consider keeping it separate from your portfolio work. You don't need to hide your casual photos—just make it more likely that the first images someone sees are the good ones.

6.2 Multiple portfolios.

Prepare Images for the Portfolio

The iPad will dutifully display the photos you add to it, but to make your portfolio look its best, you'll want to prepare the images. Despite having a great screen, the iPad offers no color management. That means the colors you worked so hard to achieve in-camera or on the computer may not match exactly when viewed on the iPad.

You also need to consider the dimensions of the images you transfer to the iPad. Although iOS will scale large images to fit, they may not appear as sharp as you'd like. They also require more of the iPad's memory. (The iPad 2 offers just 512 megabytes, or half a gigabyte, to run the operating system and all apps; the original iPad includes 256 MB.)

Both of these limitations are surmountable. Saving images in the sRGB color space (as opposed to Adobe RGB) provides the closest color fidelity between computer and iPad. For sizes, the iPad's native resolution is 1024 by 768 pixels, but most apps can handle a 4096 by 2048 pixel size, which provides plenty of resolution to zoom in and appreciate details.

Definitely create some test images to see how they appear on your iPad. Other considerations when preparing the photos include the following:

- **Crop to fill the frame.** To take advantage of the entire iPad screen, you may want to crop the images to avoid empty areas above or below the photo. Personally, I prefer to not crop, so that I retain the same composition in the final photo, but that's more of a general rule than an edict set in stone.

- **Sharpen the image for the screen.** Again, this suggestion is up to you and is worthy of testing. Sharpening the image for the screen can restore some crispness after it's been resized. Since you're outputting to a relatively low-resolution device rather than creating an image for print, I recommend sharpening a little—say, 10 percent—for the iPad.

- **Increase the saturation.** Boosting the saturation of an image can quickly push it into a dangerous realm of Vegas color, but I find that a small push of the Saturation slider (or, better, a Vibrance control if it's available, to avoid messing up skin tones) helps for the iPad's screen.

Using photo editing software on your computer, you can export copies with these characteristics for your iPad portfolio. I'm including a few common solutions here; if you use other software, the steps should be similar.

Adobe Photoshop Lightroom

When exporting photos from Lightroom, you can specify the size, color space, and other attributes, which can then be saved as a preset. For future portfolio images, you need only choose the preset to get files that are iPad-ready.

1. Select one or more photos to export.

2. Choose File > Export to open the Export dialog (6.3).

3. From the Export To pop-up menu, choose Hard Drive.

4. In the Export dialog, choose a location and a method of assigning the filename (such as the image's name or a title you assign).

5. In the File Settings area, set Image Format to JPEG and push the Quality slider to 100. Also make sure the Color Space pop-up menu is set to sRGB.

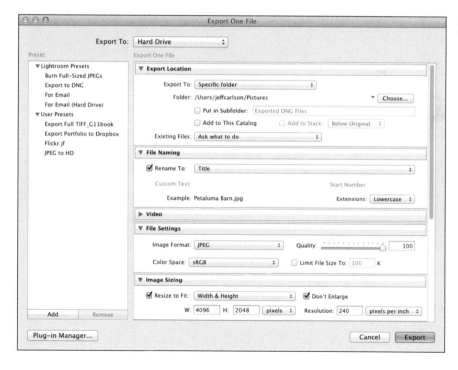

6.3 Lightroom's export options

6. Under Image Sizing, select the Resize to Fit checkbox and choose Width & Height from the pop-up menu. Set the W field to 4096 and the H field to 2048. I also recommend selecting the Don't Enlarge checkbox; if the original dimensions are smaller than 4096 by 2048 pixels, enlarging the image can introduce blurring.

7. Scroll down to the Output Sharpening section, select the Sharpen For checkbox, and choose Screen. I keep the Amount value set to Standard.

8. To save these settings as a preset, click the Add button in the lower-left corner of the dialog and give the preset a name. Click Create.

9. Click the Export button to save the file or files.

With the preset created, you can create future portfolio versions by selecting them in Lightroom and choosing File > Export with Preset > [Name of your preset].

Apple Aperture

Apple's photo organizer also offers the ability to create a preset that can output iPad-friendly images for your portfolio. Unlike Lightroom, Aperture does not offer to sharpen the file during export, so you'll need to do that before you export; I recommend choosing Photos > Duplicate Version before sharpening, so you have a separate iteration for export.

1. Select one or more images to export.

2. Choose File > Export > Version(s).

3. In the Save dialog that appears, click the Export Preset pop-up menu and choose Edit.

4. In the Image Export dialog (6.4), click the Add (+) button in the lower-left corner. A duplicate of the currently selected preset is created.

5. Rename the preset to something like "Fit within 4096 x 2048."

6. Set the Image Format pop-up menu to JPEG.

7. Set Image Quality to 12 (the highest).

8. Change the Size To pop-up menu to Fit Within (Pixels), and specify the Width as 4096 and the Height as 2048.

6.4 Aperture export settings

9. Leave the Gamma Adjust slider alone (it should be zero), and set the Color Profile to sRGB IEC61966-2.1.

10. Click OK to return to the Save dialog.

11. Specify a filename and then click the Export Versions button.

Adobe Photoshop

Photoshop's Actions and Automate tools are great for processing a lot of images quickly. Record the steps once to create an action, and you can then use it for other shots.

Create an action

1. Choose Window > Actions to show the Actions panel.

2. Click the New Action (+) button at the bottom of the panel to create a new panel. Give it a name and click Record. Any steps you take within the app will now be recorded.

3. Choose File > Image Size, and set a width of 4096 for landscape images or a height of 4096 for portrait images. (You'll need to create a separate action for each orientation.)

4. Choose Image > Adjustments > Vibrance, and use the Vibrance setting to boost the image's colors slightly.

5. Choose Filter > Sharpen > Unsharp Mask, and set an amount of sharpening you're comfortable with.

6. Save the file by choosing File > Save As, and specify JPEG as the file format, a quality of 12, and sRGB as the intended color space.

7. In the Actions panel, click the Stop button (a square icon at the bottom of the panel).

Batch-process files

With the initial settings recorded, you can batch-process images.

1. Either open the images you want to send to the iPad, or place them all in one folder on your hard disk.

2. In Photoshop, choose File > Automate > Batch.

3. In the Batch dialog, choose the action you created from the Action pop-up menu.

4. Specify where your images are located (a specific folder or images open in Photoshop) in the Source area of the dialog (6.5).

5. Set the location and the file-naming convention in the Destination area.

6. Click OK to process the files.

6.5 Batch-export files in Photoshop.

▶ **TIP** It's also possible to create a droplet, a small application that handles the automation. Instead of choosing Batch from the Automate submenu, choose Create Droplet, and then specify your iPad portfolio action and a destination. Then, whenever you want to prepare some images for your portfolio, you need only drag the photo files onto the droplet.

Adobe Photoshop Elements

The consumer version of Photoshop can accomplish almost everything its older sibling can, and in one dialog.

1. Open the files you want to process in the Photoshop Elements Editor, or group the files in a folder on your desktop.

2. Choose File > Process Multiple Files (6.6).

3. In the Process Files From area, choose Opened Files or specify the folder where the images are located.

4. Specify a location for the converted files in the Destination field.

6.6 Photoshop Elements export settings

5. Under Image Size, select the Resize Images checkbox and enter 4096 in either the Width or Height field, depending on the orientation of the images you wish to process; you'll need to process the orientations separately.

6. In the Quick Fix area, select the Sharpen checkbox.

7. Under File Type, choose JPEG Max Quality from the Convert Files To pop-up menu.

8. Click OK to process the images.

Apple iPhoto

Apple's consumer photo software doesn't offer export presets, but you can easily save a version of a photo that's sized correctly for the JPEG.

1. Select one or more images to export.

2. Choose File > Export to open the Export dialog (6.7).

3. Make sure you're in the File Export section of the dialog that appears, and set the Kind pop-up menu to JPEG.

4. Change the JPEG Quality setting to Maximum.

6.7 iPhoto export options

5. From the Size pop-up menu, choose Custom.

6. To specify the size, choose Dimension from the Max pop-up menu, and enter 4096 in the field.

7. Choose how the file will be named in the File Name setting.

8. Click the Export button.

▶ **TIP** If you have a brochure or other printed work, save it as a PDF and include it in your portfolio. You can then send it to a client via email.

Create Your Portfolio

A portfolio is essentially a slideshow of your photos, and if you want to stick with the basics, you can use the iPad's built-in Photos app to show off the images. But as you're putting a portfolio together, you'll want more control: over how photos are added and organized, over the way they're presented, and over how your client interacts with the work.

Dedicated portfolio apps offer all of those options, and you'll find many programs at the App Store. I've worked with several of them, and Portfolio for iPad (www.ipadportfolioapp.com) is my favorite. I'll use it as the model for building a portfolio on the iPad in this chapter.

Using the Built-in Photos App

If you don't want to pay for dedicated portfolio software, you can achieve similar results using the iPad's included Photos app. The trick is in getting the images to appear in the order you wish. In iPhoto or Aperture, create an album that contains the photos, and specify the order there. When you sync, the Photos app honors their placement within that album.

Create and Populate Galleries

Since this is a digital portfolio that will likely change over time, it's important to be able to easily add images to your collection now and later. The Portfolio app groups multiple portfolios into galleries—you can have just one gallery as your entire portfolio, or you can create several. To create a new gallery, do the following:

1. Tap the Configure button (the gear icon), and then tap the Manage Galleries button (6.8).

2. On the Galleries screen, tap the Add (+) button and type a name for the gallery.

6.8 Configure galleries in Portfolio for iPad.

Repeat the process to create as many galleries as you'd like. If you decide to remove a gallery, tap the Edit button at the top of the page, tap the circular red delete button that appears, and then tap Delete to confirm the deletion.

Add Photos to a Gallery

The best way to load images into a gallery depends on what's most convenient for you. I'm partial to using Dropbox, since I'm a big fan of the service anyway, and it provides a destination for the portfolio-specific images I generated earlier in the chapter. Dropbox also gives me an online

backup of my portfolio images, so if for some reason I can't use Portfolio to run a presentation, I can fall back on the Dropbox app. (If you don't use Dropbox, give it a try at www.dropbox.com—the service is free for up to 2 GB of data storage.)

Other possibilities include loading images you've previously imported or synced to the iPad's Photos app, transferring the files via iTunes, fetching files from specific URLs, or using the free Mac application Portfolio Loader, available from the developer. Here's how to do it from the iPad, from iTunes, and from Dropbox.

Load from iPad media

1. With the gallery selected in the Galleries list, tap the Load button (6.9).

2. Tap the Load from iPad Media button.

3. Using the iOS Photos picker, navigate to an album containing an image you want (6.10).

4. Tap an image thumbnail to add it to the gallery. This method allows you to load only one photo at a time.

5. Tap outside the picker to dismiss it.

6. Tap Done to finish managing galleries.

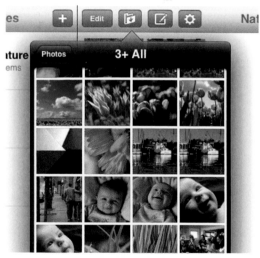

6.9 Load options

6.10 The window to your photo library

Load from iTunes

1. In iTunes on your computer, select the iPad in the sidebar and click the Apps category at the top of the window. (If you don't see your iPad in the sidebar, make sure it's connected via a sync cable or a Wi-Fi connection.)

2. Under File Sharing, scroll down to the Portfolio app and select it (6.11).

3. Click the Add button at the bottom of the Portfolio Documents pane, and locate the files you want to add. Or, you can drag the files to the pane from the Finder or from Windows Explorer. The files are copied immediately without requiring a sync operation.

4. In the Portfolio app on the iPad, go to the Galleries screen (as described earlier) and tap the Load button.

5. Tap the Load from File Sharing button (6.12).

6. In the File Sharing popover, select the photos you want to import.

7. Tap the Add button.

8. Tap Done to finish managing galleries.

6.11 Add files via iTunes.

Load from Dropbox

1. On your computer, copy any image files destined for your portfolio to a folder within your Dropbox folder.

2. In Portfolio on the iPad, go to the Galleries screen and tap the Load button.

3. Tap the Load from Dropbox button. A popover appears, containing the contents of your Dropbox folder (6.13). (Or, if you're accessing this feature for the first time, you're asked to log in to your Dropbox account.)

4. Navigate to the folder in which your images are stored.

5. Tap the thumbnails to select the photos you want to load, and then tap the Add button. The images are copied to the Portfolio app and appear in the gallery.

6. Tap Done to finish managing galleries.

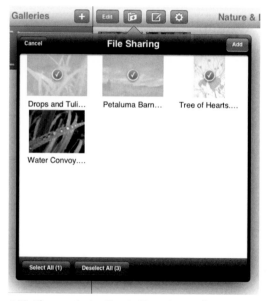

6.12 After transferring files via iTunes, import them in Portfolio.

6.13 Adding photos from Dropbox

Edit a Gallery

Here's where you put all that earlier advice to good use. Now that you have a gallery full of images, you need to put them into your preferred order and set a thumbnail for the gallery.

Reorder images

1. Return to the Manage Galleries screen in the Portfolio app.

2. Tap the Edit button above the image thumbnails; the photos jiggle and appear with close boxes (x).

3. Tap and drag a thumbnail to change its position (6.14). Do the same with the others until the photos are in the order you want them to appear.

4. To remove an image, tap its close box and then tap the Delete button that appears (6.15).

5. Tap Done when you're finished.

6.14 Drag to change the order of photos.

6.15 Remove a photo.

Choose a gallery thumbnail

1. Tap the thumbnail of the photo you wish to use as the gallery's thumbnail.

2. From the popover that appears, tap Set as Gallery Thumbnail.

3. Pinch with two fingers to resize the image to fit the visible area (in the center of the screen, not dimmed); you can also reposition the image by dragging it (6.16).

4. Tap the Save button to apply the change and assign the image as the thumbnail (6.17).

6.16 Specify the thumbnail source.

6.17 Thumbnail changed

Add a Logo Screen

To personalize the opening screen of your portfolio, the Portfolio app can display three logo screens: one for landscape orientation, one for portrait orientation, and one for an external screen when presenting with a video-out connection like a television or projector.

Tap the logo area (helpfully marked with "Tap here to place your logo"), or tap the Configure button and then tap the Customize Appearance button. Using the sizes specified on the Customize Appearance screen, create a set of images that act as a virtual cover for the portfolio. The pixel dimensions are important: The app won't simply crop an image you throw at it; it will resize the image to fit (6.18).

Tap one of the placeholders, and load the corresponding image using the techniques described earlier.

> ▶ **TIP** If you don't want to be restricted by the app's logo screen dimensions, create black (or white, or anything else suitably forgettable) versions of the logo images. Then, create a 1024 by 768 logo image and set it as the first photo in your portfolio. You can then bypass the initial navigation and launch your presentation from within the gallery.

6.18 Set three custom images for your portfolio's main screen.

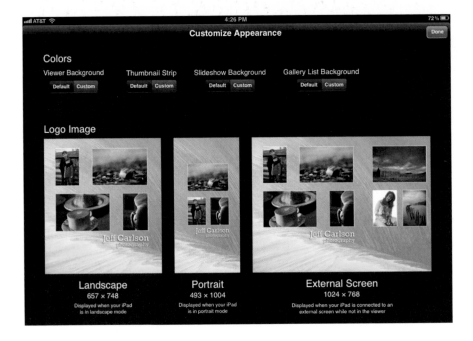

Present Your Portfolio

Depending on the client or target audience, you may choose to run the presentation yourself on the iPad, let the photos play in a slideshow, hand the iPad to the viewer, or display on an external television or projector.

Before you begin your presentation, it's a great idea to restart the iPad by powering it off and powering it back on again, which resets the memory. That reduces the chances that the software will stall while shuffling large images in and out of active memory.

Rate and Make Notes on Photos in Portfolio for iPad

The Portfolio for iPad app can also be used to get feedback from someone on the images in your portfolio; for example, suppose you're showing your selects from a photo shoot and want the client to choose a set of favorites. They can rate and comment on individual photos.

1. In a gallery, tap the Note button near the gallery name.

2. Tap a star to assign a rating.

3. Tap the Notes field, and type a comment (6.19).

4. Tap outside the popover to dismiss it.

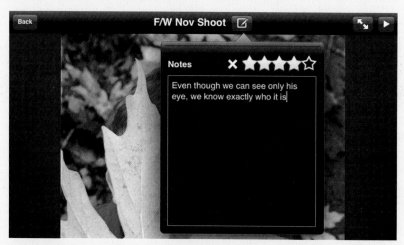

6.19 Rate and make notes in Portfolio for iPad.

Present on the iPad

Presenting your portfolio can be as easy as running a slideshow in the Photos app, but again, you'll appreciate some of the other features that a dedicated portfolio app can bring. I'll use Portfolio for iPad as an example.

Tap a gallery to view the first photo it contains (6.20). Here, you can tap a thumbnail at the bottom of the screen to jump ahead and view any image in the gallery. For the best presentation, however, I prefer tapping the Full Screen button to view one image at a time. Flick between images by swiping left or right on the screen. (Tap once on the screen to reveal the controls if you want to exit full-screen mode.)

▶ **TIP** With the thumbnail strip visible, double-tap a photo other than the one currently displayed; the two photos appear side by side (6.21). Double-tap again to return to the thumbnail strip.

To view an image in more detail, pinch outward or double-tap a photo to zoom in. Double-tap again or pinch inward to see the entire image.

For a self-directed presentation, tap the Play button in the upper-right corner to run the photos as a slideshow.

▶ **TIP** If you're handing the iPad to a client, you can lock the editing interface in Portfolio for iPad to prevent them from accidentally editing your gallery. On the Portfolio title screen, tap the gear icon and then tap the Lock button. Specify a four-digit passcode that must be entered to access the editing features. This lock applies only within the app; a client can still access the rest of your iPad by pressing the device's Home button.

Present on an External Display

The iPad's screen is a good size for presenting to one or two people, but if you need to show your portfolio to more, moving the images to a larger display like an HD television or a projector can make quite an impact.

Wired

Connect the iPad to a TV or projector by using an HDMI, VGA, or component cable, depending on the available connections. Apple sells iPad adapters for each type of plug.

Play

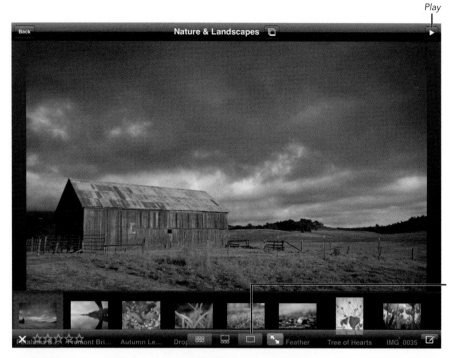

6.20 Presentation with thumbnails visible

Full Screen

6.21 Compare two images side by side.

After connecting the iPad to the device, open Portfolio for iPad. If you specified a custom logo page for the largest size, it should appear on the external display. When you enter a gallery, the first image shows up. You can then direct the presentation from the iPad or start a slideshow. (As I write this, it's not yet possible to zoom an image on the external display.)

If you're using an iPad 2, connecting it to the device mirrors the screen, so your viewers can see exactly what you see on the iPad. However, in Portfolio for iPad, only the images appear, not the thumbnails. Swipe to switch between photos, or tap the Play button to start a slideshow.

Wireless

If you have an iPad 2 or later and a second-generation Apple TV (the small black model) at your disposal, and they're both on the same Wi-Fi network, you can display the portfolio wirelessly using AirPlay. To make the two devices communicate, do the following:

1. Double-click the Home button to reveal the iPad switcher bar.

2. Swipe left to right to reveal the brightness, music playback, and volume controls.

3. Tap the AirPlay button, which appears to the right of the fast-forward button. If the AirPlay button isn't there, verify that the iPad and Apple TV are both connected to the same network, that the Apple TV is powered on, and that AirPlay is enabled in the Apple TV's settings.

4. Tap the name of the Apple TV in the AirPlay popover.

5. Set the Mirroring switch to On (6.22).

Now, without being physically tethered to the TV or projector, run your presentation from the iPad.

6.22 Connect to the Apple TV using AirPlay.

Share Photos

Yes, it's true. I do, on occasion, import photos from my camera into the iPad, sort and edit them, and then upload selected shots to photo-sharing services…from my couch. Even when my laptop is sitting just a few feet away, I don't want to retreat to my upstairs office and get into working mode. I want to browse shots from the day, get feedback from my family there in the same room, and put something up that friends can view online.

You needn't aspire to be as lazy as me, but there are many opportunities to share photos directly from the iPad before they inevitably end up on a computer. You may want to post shots from a just-concluded wedding, or maybe a client located elsewhere needs to review and rate images quickly. Several options for sharing your photos from the iPad are available beyond simply syncing the photos to a computer.

Upload Images to Photo-Sharing Services

In the early days of the Web (I'm dating myself here), when you wanted to publish a photo online you needed to be savvy enough to upload the image to a server and write the HTML code necessary to make it appear. Now, with popular photo services such as Flickr, Facebook, and others, you can let the software handle all of that.

Upload from Editing Apps

Most of the photo-editing apps allow you to upload your images directly to Facebook, Flickr, Twitter, Dropbox, and others. The steps are similar in most apps, but since I focused on Snapseed and Photogene in Chapter 4, I'll detail those steps here.

Upload from Snapseed

Snapseed uses the iOS convention of making exporting options available from the Share button; it supports Flickr, Facebook, and Twitter.

1. With a photo already loaded in Snapseed's initial screen, tap the Share button (7.1).

2. Tap the name of the service you want to use.

 The first time you share something, you need to log in to the service to grant the app permission to add items to your account. Twitter support exists at the operating system level, so if you haven't done so previously, go to Settings > Twitter and enter your account information. Also make sure that the Allow setting for the app is set to On.

3. Depending on the service, enter a caption, a description, a destination, and privacy options. Facebook, for example, is limited to a caption and choice of album (7.2); if you don't choose an album, it creates a Snapseed Photos album. Flickr, on the other hand, lets you add keywords and specify who gets to view the photo once it's uploaded.

4. Tap the Publish button to upload the image.

7.1 Snapseed's sharing options

7.2 Choose a Facebook photo album.

▶ **TIP** To control who views your photos on Facebook, you need to set up privacy options in your Facebook account. Locate your photo albums, and then click the drop-down menu just below each one to specify Public, Friends, Only Me, or Custom. (Facebook changes its interface often enough that I'm not even going to try to walk you through the steps of locating that control. But once you get to the albums, it should be obvious.)

Upload from Photogene

Photogene offers more services to upload to, and it also gives you options such as image size and, in the pro version, a watermark.

1. Open a photo and edit it as you wish.

2. Tap the Export button (**7.3, on the next page**).

3. Tap the Resolution\Resize button to specify the image size. In most cases you'll probably want to choose Original, but not always; you may want to upload a smaller version when you don't have much available bandwidth (or maybe you just prefer not to upload full-size photos). The numbers in the Resolution\Resize popover represent the image's longest dimension. Choosing 1024, for example, resizes a landscape photo to 1024 pixels wide but resizes a portrait photo to 1024 pixels tall.

 The pro version of the app adds the ability to set the JPEG quality by specifying the level of compression that's applied.

7.3 Export options in Photogene

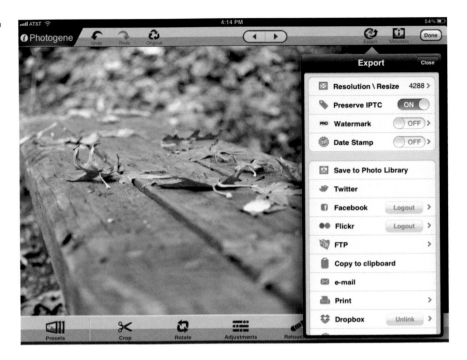

4. If you want to strip any metadata you added before uploading, switch the Preserve IPTC option to Off.

5. Tap the name of the service or feature you want to use. If you haven't previously set up a service, you're asked to log in and grant Photogene permission to add photos.

6. In the service's details panel, enter a title, a description, and other information that applies, including the privacy level.

7. Tap the Share button. Photogene prepares the photo and uploads it.

iCloud Photo Stream

I want to mention Apple's iCloud Photo Stream briefly here because if you're an iCloud subscriber, photos are automatically uploaded from your iPad's Camera Roll. However, Photo Stream is really designed for an audience of one: you. Yes, you can access your photos from any of your connected devices, but you can't point a friend at photos in your stream as was possible with the old MobileMe service.

To Watermark or Not?

I find watermarks distracting, so I generally don't bother to watermark my photos. I want viewers to focus on the photo, not the mark. I'm also not too concerned about getting ripped off—unless I splash a watermark over the entire image, someone stealing the photo can easily remove the mark. However, there are instances when a watermark can be appropriate. Wedding photographers can benefit from having their logo, web address, or other branding appear on photos that many people will see (the final versions that go to the bride and groom, of course, would be free of marks). You can also use a watermark to indicate that a photo is a proof versus a final version.

Photogene's watermark support (available only after you've paid for the pro version) allows you to specify an image as a watermark and place it on an exported photo. Create your logo or other mark and copy it to the iPad's Photo Library. Then, in Photogene's Export popover, do the following:

1. Tap the Watermark button.

2. Tap Select Image and choose the watermark image you created.

3. Using the sliders in the popover, adjust the opacity of the image and the amount of padding around it **(7.4)**.

4. Choose a position for the mark by tapping one of the boxes in the proxy grid. Note that the preview doesn't accurately convey the size of the mark; it's enlarged to show relative position.

5. Tap the Export button at the top of the popover to return to the rest of the Export options.

6. To include the watermark, switch the Watermark option to On. The watermark appears on the photo that's exported **(7.5)**.

7.4 Setting a watermark

7.5 Watermark applied

Upload Photos Using Services' Apps

Photo services have been quick to create their own iOS apps, mostly for use with the iPhone so people can upload the shots they take with its camera. For snagging pictures that you have imported and don't need to edit, a dedicated app provides a more direct path from your iPad to your online photo album. In some cases, you can upload photos in batches instead of one at a time.

The first step is to visit the iTunes Store and see if your preferred photo service offers an iOS app. You're also sure to find third-party apps that view photos and upload them to the services. Here are a few that I use, both "official" and third-party apps.

Flickr

Despite the fact that Flickr is one of the largest photo-sharing sites on the Web, its iOS app hasn't changed much in several years. Still, even though it's not optimized for the iPad, the app does make it easy to upload multiple photos to your Flickr photo stream.

1. At the opening screen, tap the Upload button and choose Upload from Library.

2. Choose the album that contains the photos you want to upload. At this stage, you can choose photos only from one album, but you'll have a chance later to add more photos.

3. Tap to choose photos, which gain a green checkmark, and tap Done to continue.

4. On the Details screen that appears, optionally assign the photos to sets, add tags, and specify whether to upload them at full resolution or medium resolution (7.6). You can also tap a photo thumbnail to edit details for just that item.

5. Decide who can see the photos online by choosing a setting in the Privacy Level area.

6. If you want to include other photos in the upload, tap the Add Item button and select them.

7. Tap the Upload button to transmit the photos.

► **TIP** If you prefer an iPad-native Flickr client, check out Flickr Studio.

SmugShot

SmugMug, a popular site for more-experienced photographers, offers an official SmugMug app, but it's geared toward *viewing* photos by you and others. Since I'm focusing on sharing in this chapter, go get SmugShot, an iPhone app that is designed to upload photos you capture or pull from your Photo Library. You can add several photos to the queue and then upload them all at once (7.7).

PhotoStackr for 500px

The newest entrant in the photo-sharing field is 500px, a site that boasts a great viewing experience and a growing number of professionals. The company's 500px app is a model for how to browse photos on a tablet, but it doesn't offer any way to upload new photos to one's account.

Instead, turn to PhotoStackr for 500px, which adds uploading and a few other features to the browsing experience. As with the Flickr and Smug-Shot apps, you can queue several photos to be uploaded together.

7.6 Uploading photos in the Flickr app

7.7 SmugShot's upload queue

7.8 Uploading a single image to Photoshop.com using the Photoshop Express app

Photoshop Express

The Photoshop Express app acts as the window to Photoshop.com, Adobe's own photo-sharing and editing Web site. The Photoshop Express app will prove particularly useful if you use Photoshop Elements, which ties into Photoshop.com.

1. In the app, tap the Share button in the toolbar.

2. Tap the Select Photo button.

3. Choose a photo from your library.

4. Tap the Photoshop Express button to view a list of online albums.

5. Select an album and optionally enter a photo caption in the text field at the bottom of the popover (7.8).

6. Tap the Share button to begin uploading.

▶ **TIP** Although you must pick photos one at a time for uploading, the Photoshop Express app builds a queue of jobs to send. Tap the Share Progress button to see what's been uploaded and what's pending.

Email Photos

A fallback for getting your photos out there is to send them as email attachments. This capability is built into the core of iOS and is available from nearly every app.

I call this approach a "fallback" because, honestly, the current state of email makes it difficult to guarantee that the message will get through. Image attachments are usually large, which increases the chances that the message will stall at a server en route from you to your recipient. Or, the message could be marked as spam and shunted into a person's queue of suspect emails with the usual assortment of get-rich-quick scams and unwanted product solicitations.

Share a Single Photo

Still, email is convenient and widely supported. But there's a trick. Unlike most desktop email programs, where you compose a message and then attach a photo to it, on the iPad the process is reversed: You start with the photo first and then choose to send it via email, like so:

1. Open the Photos app to view your image library. (If you're in a third-party app that offers email as an export option, follow its steps. I'm starting here as if you have just picked up the iPad and want to share a photo from the built-in library.)

2. Locate the photo you want to share, and tap to view it full screen.

3. Tap the Share button and choose Email Photo from the popover list of options. A new outgoing message appears, with the photo in the body of the message.

4. Fill in the To and Subject fields to address the message.

5. Tap the "Images" text to the right of the Cc/Bcc, From field to specify the size of the outgoing image (7.9).

7.9 The image-size control is almost invisible.

6. Choose one of the Image Size options by tapping it (7.10).

7. Tap the Send button to dispatch the message.

Share Multiple Photos

To attach more than one photo to an outgoing message, you need to follow a slightly different approach:

1. In the Photos app, open the album containing the images you want.

2. Instead of viewing one full-size, tap the Share button. The toolbar reads Select Photos, and the buttons there change.

3. Tap to select the photos you'll soon be sending.

4. Tap the Share button—this time, a button labeled "Share," not the pervasive icon with an arrow coming out of a square.

5. Choose Email from the popover that appears (7.11). The photos become part of an outgoing message.

6. Fill in the To and Subject lines, set an image size (which applies to all of the photos), and then tap the Send button.

7.11 Mark multiple messages and attach them to one outgoing message.

7.12 iMessage or MMS is often a faster way to get a photo to someone.

▶ **TIP** One way to circumvent email but deliver a photo to a specific person is to use MMS (Multimedia Messaging Service) or iMessage instant messaging. In the Messages app, tap the camera icon to the left of the text field, locate your image, optionally write a note, and tap the Send button (7.12).

▶ **TIP** One advantage to email is that it can act as a workaround when other uploading options fail. My Flickr account, for example, gives me a personal email address. Any image attachment I send to that address is added to my photo stream, which uses the contents of the Subject field as the photo's title and the text in the body of the message as the description. Check your favorite service for a similar option.

Share Photos Using Adobe Revel

As you've no doubt discovered, many photo-sharing services vie for your attention and image libraries. Adobe, digital imaging powerhouse that it is, jumped in with Photoshop.com and Photoshop Express for iOS. However, late in 2011, it also started a separate service called Adobe Revel, which doesn't currently communicate with Photoshop.com (although it is integrated into Photoshop Lightroom 4, which is in public beta as this book goes to press).

Revel offers a very cool feature that soothes a photography pain point. You can share a set of photos, called a carousel (reminiscent of the circular trays of slides you'd load into a slide projector), with other people. They can rate the photos, and even use the software's editing tools, without stepping on your versions of the images. So, when I come back from vacation and my wife wants to look through my library and pick out her favorites, I can create a new carousel for her to browse on her computer or iOS device. I can see her picks in my library, but they don't overwrite mine.

The Adobe Revel software is free, but the service costs $5.99 a month (a 30-day trial period is free). It's currently available for iOS and Mac OS X; Windows and Android versions are still in development.

Import Photos to a Carousel

After you install the app and log in with your Adobe ID (or create a new ID if you don't currently have one), do the following:

1. Tap the plus sign (+) button to create a new carousel.

2. From the popover that appears, choose Choose Existing Photos.

3. Navigate to an album, such as the Camera Roll, and tap to select the photos you wish to import.

4. Tap Done to begin importing the photos, which appear grouped by date (7.13). Revel also uploads the images to Adobe's servers for backup and syncing to other devices on which you install the software.

Rate and Edit Photos

When I say "rate" in regards to Revel, what I really mean is to mark a photo as a favorite; there are no multiple-star rankings. Instead, tap a photo to open it, and then tap the star button in the lower-left corner of the screen.

To edit photos, tap the Develop button and use the controls in the toolbar to apply preset looks, adjust color and tone, or crop and rotate the image. (See Chapter 4 for more detail on these types of tools, though I don't cover Revel specifically there.)

▶ **NOTE** In the spirit of sharing, Revel also enables you to upload a photo via Facebook, Twitter, Tumblr, and Flickr or to send it via email. Tap the Share button and choose an option.

Collaborate with Others

Here's where I find Revel the most interesting. From within Revel, you can share a carousel with someone else who has an Adobe ID, even if they don't subscribe to Revel. Here's how:

1. On your iPad, tap the Settings button (the gear icon) to view your list of carousels in a popover.

2. Tap the Detail (>) button for the carousel you intend to share.

3. In the Sharing With section, tap the Add User button (7.14). (You can share a carousel with up to five people.)

4. Type the email address of the person who will share the carousel, and then tap Done.

5. Tap Done at the top of the popover to send an invitation.

7.14 Share the carousel with someone else.

When the other person installs the Revel software and signs in, they're asked if they want to join your carousel. After they do, the same rating and editing features are available. Images are updated nearly in real time, so when they mark a photo as a favorite, a gray flag indicates it's been marked by someone else (7.15). (The number in the flag tells you how many people have marked it.)

And because Revel also works on the Mac, when I get back to my computer, the files are already present in the desktop version of Revel, and they reflect the ratings and edits made while reviewing.

7.15 The other reviewer marked these two barn photos as favorites.

Print Photos from the iPad

When you think of printing from the iPad, you probably envision making a paper copy of an airline boarding pass or a text-only page of notes. Or, your first thought is, "The iPad can print?" The options for taking content from the iPad and putting it on paper are still relatively slim—a few Wi-Fi–enabled printers support Apple's AirPrint technology, for example. However, photos originated in the print world, and it is possible to transfer your images into ink-on-paper reproductions.

▶ **NOTE** Keep in mind that the iPad doesn't offer color management, so I wouldn't rely on it for professional output. Run your photos through a color-managed desktop workflow for the best results for clients, gallery shows, and the like.

Print from Nearly Any App

Since it's not possible to plug a printer into an iPad, any printing you do must occur wirelessly. If you own an AirPrint-compatible device, that's no problem: Tap the Share button in the Photos app, tap the Print button, and configure any printer-specific options.

If you own a perfectly good printer that doesn't support AirPrint, it's still possible to make it work. Using a utility called Printopia under Mac OS X,

any printer on the network that's accessible by your Mac is available (7.16). In fact, Printopia can also "print" to your Dropbox account, to folders on your computer, or directly to applications (7.17). Under Windows, check out Collobos Software's FingerPrint utility, which does the same thing.

The major printer manufacturers, like Epson, Lexmark, and HP, also offer free printing utilities for iOS that take advantage of their devices' features. (Make sure you check compatibility with your printer.)

Order Prints

A few companies are getting wise to the fact that some people use their iOS devices more than computers (or own just iPads), so they're developing apps that send images directly to print vendors. The app for the drugstore Walgreens, for example, lets you upload photos and then order prints or cards that you can pick up at the closest location.

Other fun apps include PopBooth, which takes photo booth–style snapshots and gives you the option of ordering a physical photo strip, and Sincerely Ink, which makes greeting cards from templates and your photos (7.18).

▶ **NOTE** If you're looking to order a print that's of higher quality than a snapshot from the iPad, a combination of an app and the Web might be the way to go. At the Web site Zenfolio (zenfolio.com), you can use the service Mpix.com to create and distribute prints. From my storefront (jeffcarlson.zenfolio.com), I can upload photos and then access the site in Safari to place an order.

7.16 Choose a printer and the number of copies, and hit Print.

7.17 Printopia prints to destinations other than printers.

7.18 Sincerely Ink orders printed cards containing your photos directly from the iPad.

 LightTrac

 Visuals

 Timelapse

 Big Picture

 PhotoCalc

 GeotagPhotos

 Easy Release

 Eyewitness

 WeatherBug

 GoodReader

 VelaClock

 Strobox

 PhotoSync

 Photosmith

 Portfolio

 Snapseed

 Safari

 Mail

 Music

 Flipboard

 Instap

HelloPhoto

500px

Intellicast HD

Photogene

Twitterrific

Helpful Apps for Photographers

As I type this, there are something like 2600 apps in the Photo & Video category of the iTunes Store. A lot of them share the same functionality; all sorts of apps add effect presets to images, for example. But there are also plenty of gems that provide specialized features, such as a way to produce legal model releases for signing on the spot, or to calculate when tomorrow's sunrise will emerge and which angle the light will be coming from.

This chapter contains a host of apps that will help photographers, but it doesn't repeat any of the excellent app suggestions made elsewhere in the book; see the appendix for a full list of apps mentioned in these pages. You'll also notice that some are iPhone apps—that means they haven't been designed to run specifically on the iPad (taking advantage of its larger screen, for example), but they still work fine.

The iPad on Location

VelaClock Sun/Moon

More than just a world clock, the VelaClock Sun/Moon app is handy for planning sunset or sunrise photo shoots in far-flung locales. In addition to displaying global times for popular cities, it also gives a graphical view of astronomical twilight, nautical twilight, and civil twilight—all at both dawn and dusk. You can also create custom locations by entering longitude and latitude information. To get a "golden hour" forecast for your destination, tap the calendar icon to select a specific date or to incrementally view by hour, day, week, month, and year. Tapping a location also provides moonrise and moonset times, plus the altitude and azimuth of the sun and moon.

$3.99, iPhone app
http://veladg.com/
http://itunes.apple.com/us/app/velaclock-sun-moon/id418495249

PhotoCalc

Whether you're working in the field or in the studio, PhotoCalc is a handy one-stop toolbox for calculating depth of field, exposure reciprocation (for shutter speed, aperture, and ISO), and flash exposures. It also includes a solar calculator for sunrise, sunset, and twilight times based on your current location or one of the many global presets. And its calculations can be geared toward your specific camera (selected from an extensive list) or one of a variety of film formats. As a bonus for new photographers, it also features a handy glossary of terms, as well as explanations of the zone system and the Sunny 16 rule.

$2.99, iPhone app
http://www.adairsystems.com/photocalc/
http://itunes.apple.com/us/app/photocalc/id287811118

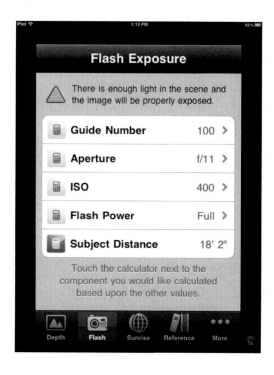
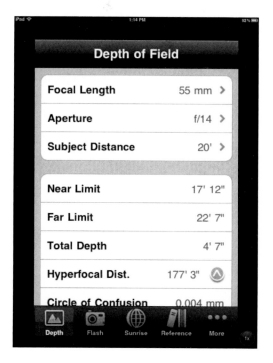

Intellicast HD and WeatherBug

For a more immediate view of conditions for your shoot, you should outfit your iPad with a reliable weather app. The App Store is chockablock with weather titles, but the best apps give you up-to-date radar views with good customization capabilities. The Intellicast HD app offers up to four active radar overlay options—from precipitation to cloud cover to storm tracks—that you can toggle between. WeatherBug for iPad offers even more overlay customizations (including wind speed), and it pulls data from a variety of localized sources that can provide more specific data.

Intellicast HD: Free, iPad app
http://www.intellicast.com/
http://itunes.apple.com/us/app/intellicast-hd/id408451987

WeatherBug for iPad: Free, iPad app
http://weather.weatherbug.com/mobile/weatherbug-elite-apple-ipad.html
http://itunes.apple.com/us/app/weatherbug-for-ipad/id363235774

LightTrac

Now that the weather looks all clear and you've got the time just right for the sunset, it's time to set up your shoot to maximize natural lighting conditions. The LightTrac app calculates and plots the angle and elevation of both the sun and the moon for any given date and time. Once you choose your location, the app shows three lines for the angle of the sun: sunrise, sunset, and the current time. Use the slider at the bottom of the screen to adjust the time of day to find where the sun will be for your shoot.

$4.99, iPad/iPhone app
http://www.lighttracapp.com/
http://itunes.apple.com/us/app/lighttrac/id392892355

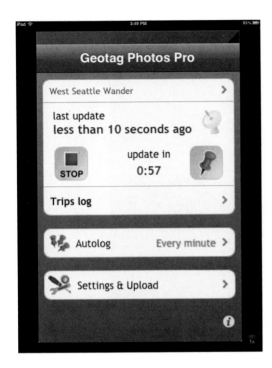

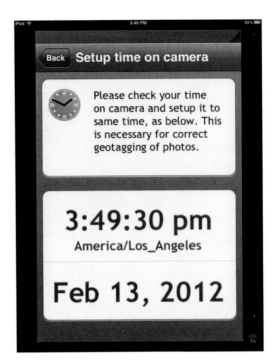

Geotag Photos Pro

Having location data added to your photos is both practical and fun. If you don't have a GPS-enabled camera or memory card, the Geotag Photos Pro app is the next best thing. After the app records your position, it runs in the background and logs location data at selected intervals (from continuous to once an hour). Matching the app's coordinates with your photos requires sending the data file from the app to the Geotag Photos Web site and then downloading the data to a Java-based desktop application that will save the matched GPS coordinates into a photo's EXIF data. A GPX file can also be sent via email from the iPad app for importing into Aperture. Geotag Photos Pro works best with the 3G version of the iPad, which includes built-in GPS. You can still use it with the Wi-Fi–only iPad, but you'll need to be connected to a Wi-Fi network to get location data.

$3.99, iPhone app
http://www.geotagphotos.net/
http://itunes.apple.com/us/app/geotag-photos-pro/id355503746

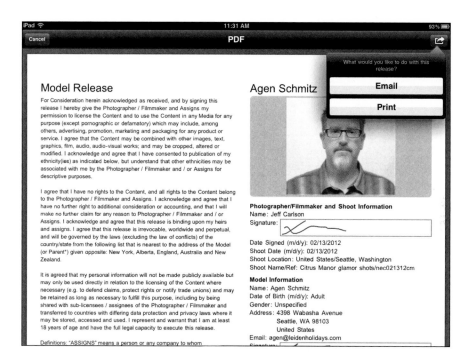

Easy Release

To keep everything on the up-and-up, you'll need signed legal releases from your shooting subjects. You could keep a stack of photocopied forms available, but with the Easy Release app you can help yourself go paperless, and it's handy for getting signatures when on the go. It includes industry standard model and property releases, which can be fully customized. After your model types in his or her details, a signature can be made right on the iPad's screen and then the finished release is created as a PDF for sending via email or printing via AirPrint.

$9.99, iPad/iPhone app
http://www.applicationgap.com/apps/easyrelease/
http://itunes.apple.com/us/app/easy-release-model-release/id360835268

GoodReader for iPad

I used to carry a copy of my camera's instruction manual in my camera bag, just in case I needed to look up some obscure feature or troubleshoot something. Even slicing out the non-English portions of the book left me with a heavy little chunk of pressed paper. Instead of abandoning the information altogether, I downloaded PDF versions of my camera manuals and other information and put them into GoodReader for iPad. Although iOS can read PDF files natively, and you can store them in iBooks or other ebook readers, GoodReader is unexpectedly versatile. Not only can it read PDFs, it can pull them from (and upload them to) sources such as iCloud and Dropbox, and it can play audio and video files.

$4.99, iPad app
http://www.goodreader.net/goodreader.html
http://itunes.apple.com/us/app/goodreader-for-ipad/id363448914

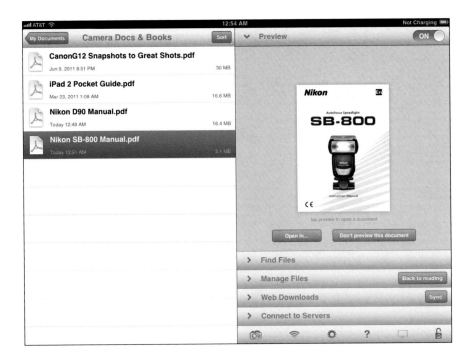

The iPad in the Studio

Strobox

While it won't help you with the nuances of creating a lighting setup for your studio, the Strobox app is a good tool for documenting how your studio lights were arrayed during your shoots. Starting from a blank grid pattern, you can add icons for a variety of lighting instruments—from softboxes to diffusion panels and strobes—and then manipulate their positioning. Once you diagram your lighting, you can save it for future reference, send it via email, or save it to your iPad's Photos app.

Free, iPhone app
http://strobox.com/app
http://itunes.apple.com/us/app/strobox/id339112815

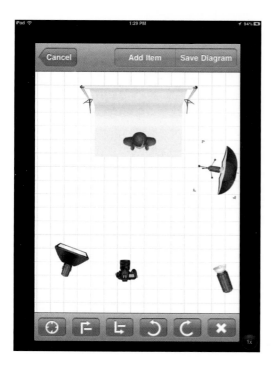

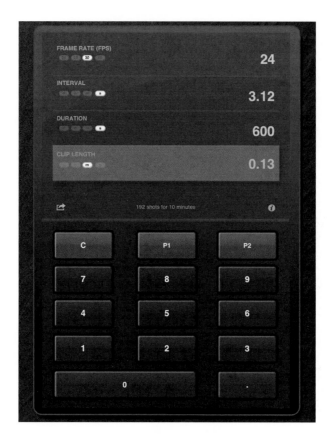

Timelapse Calculator

For creating videos of timelapse photography, you'll need to do some math to calculate the interval between shots to get you to the desired length of your movie. The Timelapse Calculator app relieves you of having to flash back to your calculus class by computing how many shots you'll need to take—and at what interval—during a set time to arrive at your clip's duration. You can also email the resulting calculations from the app.

$0.99, iPad/iPhone app
http://www.cateater.com/
http://itunes.apple.com/us/app/timelapse-calculator/id495062782

HelloPhoto

The HelloPhoto app can be used simply as a light table for your iPad to view and sort slides and negatives, and it includes full-screen viewing as well as trays for 35mm slides, 35mm negatives, and 120/200 film. However, if you add another camera-enabled iOS device to the mix (iPhone, iPod touch, or another iPad), you can use the app on that second device to capture an image of a negative placed on the HelloPhoto light table and turn it into a positive image. The result might not be of pristine quality, but it's good enough for sharing with Facebook friends.

$1.99, iPad/iPhone app
http://www.lightpaintpro.com/?p=316
http://itunes.apple.com/us/app/hellophoto/id417608961

Portable Inspiration

Visuals by Vincent Laforet

One of the best ways to keep your creative mojo working is to see what other photographers are doing and practice some of their techniques. The Visuals by Vincent Laforet app features some stunning photos by the Pulitzer Prize winner, and each image is accompanied by exposure details and a video of Laforet explaining how the shot was accomplished, with tips on composition and technical details. The app also provides external links for buying prints and for purchasing equipment used to shoot the photos, and you can also save images to the Photos app for use as wallpaper.

$2.99, iPad/iPhone app
http://itunes.apple.com/us/app/visuals-by-vincent-laforet/id385216668

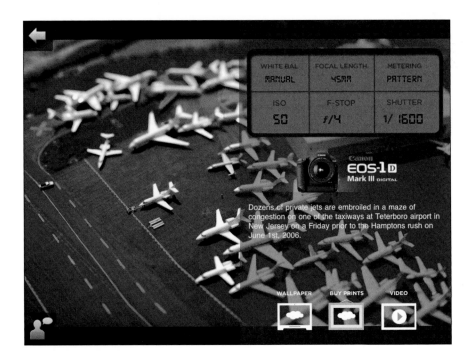

The Guardian Eyewitness and The Big Picture

For a wider lens on news photography, The Guardian Eyewitness app replicates the London newspaper's Eyewitness section, where a single image is printed in full color across a center spread. The app showcases just one striking image per day and offers the last 100 daily images. At the bottom of each image you'll find a caption to give the picture context, as well as a pro tip. Save images to a Favorites list and share to Twitter and Facebook.

While The Big Picture app from the Boston Globe only publishes photos three times a week, you get to dive into a larger collection (ranging from 20 to 40 images) that is based on a theme or a specific news event. The Big Picture also offers share connections to Twitter and Facebook, and you can save an image to the Photos app to set it as your wallpaper.

The Guardian Eyewitness: Free, iPad app
http://www.guardian.co.uk/ipad
http://itunes.apple.com/us/app/the-guardian-eyewitness/id363993651

The Big Picture from Boston.com: $2.99, iPad/iPhone app
http://itunes.apple.com/us/app/big-picture-from-boston.com/id370709214

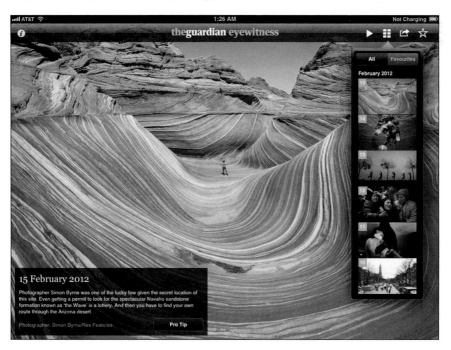

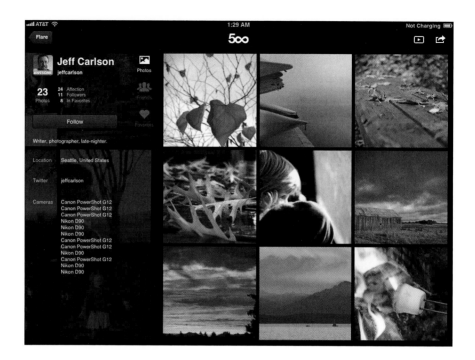

500px

More than just a photo-sharing site, 500px has been attracting work from highly skilled photographers since its original incarnation as a curated LiveJournal community. It's now open to the public with both free (with limited upload capability) and paid (unlimited upload) memberships. But the essence of its beginnings is still in evidence on the Web site and in the 500px app, where you can browse through a cornucopia of dazzling imagery from professionals and amateurs alike. As you move through lists of photos (arranged under Popular, Editors, Upcoming, and Fresh), you can give a thumbs-up to images to help them float to the top of the heap, as well as add favorites to your list. Unfortunately, you can't upload photos to the site through the iPad app (but see Chapter 7 to learn how you can do so using another app).

Free, iPad app
http://500px.com/ipad
http://itunes.apple.com/us/app/500px/id471965292

http://www...
http://itunes.app...

Chapter 4: Edi...

Photogene for...
http://www.mob...
http://itunes.a...

App Reference

I knew there would be a lot of iPad apps mentioned in this book when I started, but I didn't want to pepper every paragraph with an app name, the price, and a lengthy link to the iTunes Store. Instead, this handy reference breaks down all the apps mentioned throughout each chapter, organized alphabetically, so you can find and investigate the apps easily. Where possible, I've included links to developers' Web sites, which often feature videos of the apps in action and more detail than what appears at the iTunes Store.

The iTunes Store links are regular Web addresses: Plug them into your favorite Web browser, which will redirect you to the product's page in iTunes.

Chapter 1: The iPad on Location

Dropbox (Dropbox), Free

http://www.dropbox.com

http://itunes.apple.com/us/app/dropbox/id327630330

Eye-Fi (Eye-Fi), Free

http://www.eye.fi/

http://itunes.apple.com/us/app/eye-fi/id306011124

GarageBand (Apple), $4.99

http://www.apple.com/apps/garageband/

http://itunes.apple.com/us/app/garageband/id408709785

iMovie for iOS (Apple), $4.99

http://www.apple.com/ipad/from-the-app-store/apps-by-apple/imovie.html

http://itunes.apple.com/us/app/imovie/id377298193

Photosmith (C² Enterprises), $17.99

http://www.photosmithapp.com

http://itunes.apple.com/us/app/photosmith/id427757668

PhotoSync (touchbyte GmbH), $1.99

http://www.photosync-app.com

http://itunes.apple.com/us/app/photosync-wirelessly-transfers/id415850124

PlainText (Hog Bay Software), Free

http://www.hogbaysoftware.com/products/plaintext

http://itunes.apple.com/us/app/plaintext-dropbox-text-editing/id391254385

ShutterSnitch (2ndNature Software), $15.99

http://www.2ndnaturesoftware.com

http://itunes.apple.com/us/app/shuttersnitch/id364176211

Skype for iPad (Skype), Free

http://www.skype.com

http://itunes.apple.com/us/app/skype-for-ipad/id442012681

SoftBox Pro for iPad (EggErr Studio), $2.99

http://itunes.apple.com/us/app/softbox-pro-for-ipad/id415056105

SugarSync (SugarSync), Free

http://www.sugarsync.com

http://itunes.apple.com/us/app/sugarsync/id288491637

Chapter 2: The iPad in the Studio

Adobe Nav for Photoshop (Adobe), $1.99

http://www.photoshop.com/products/mobile/nav

http://itunes.apple.com/us/app/adobe-nav-for-photoshop/id426614130

Air Display (Avatron Software), $9.99

http://avatron.com/apps

http://itunes.apple.com/us/app/air-display/id368158927

Capture Pilot (Phase One), Free*

http://www.phaseone.com/capturepilot

http://itunes.apple.com/us/app/capture-pilot/id404906435

Capture Pilot requires Phase One's $399 Capture One Pro software.

DSLR Camera Remote HD (onOne Software), $49.99

http://www.ononesoftware.com/iphone/

http://itunes.apple.com/us/app/dslr-camera-remote-hd/id417693635

ioShutter (enlight photo), Free

http://www.ioshutter.com/

http://itunes.apple.com/us/app/ioshutter/id452177712

iStopMotion for iPad (Boinx Software), $4.99

http://boinx.com/istopmotion/ipad/

http://itunes.apple.com/us/app/istopmotion-for-ipad/id484019696

iStopMotion Remote Camera (Boinx Software), Free

http://boinx.com/istopmotion/ipad/

http://itunes.apple.com/us/app/istopmotion-remote-camera/id484024876

Remote Shutter (iAppCreation), Free

http://www.iAppCreation.com/

http://itunes.apple.com/us/app/remote-shutter-camera-live/id425583380

Chapter 3: Rate and Tag Photos

Photogene for iPad (Mobile Pond), $2.99

http://www.mobile-pond.com/mobile-pond/products.html

http://itunes.apple.com/us/app/photogene-for-ipad/id363448251

Photosmith (C² Enterprises), $17.99

http://www.photosmithapp.com/

http://itunes.apple.com/us/app/photosmith/id427757668

Pixelsync (Code Foundry), $9.99

http://www.pixelsyncapp.com/

http://itunes.apple.com/us/app/pixelsync/id409409239

Chapter 4: Edit Photos on the iPad

Photogene for iPad (Mobile Pond), $2.99

http://www.mobile-pond.com/mobile-pond/products.html

http://itunes.apple.com/us/app/photogene-for-ipad/id363448251

PhotoRaw (Alexander McGuffog), $9.99

http://sites.google.com/site/iphotoraw/

http://itunes.apple.com/us/app/photoraw/id413899112

piRAWnha (Cypress Innovations), $9.99

http://pirawnha.com/

http://itunes.apple.com/us/app/pirawnha/id409747795

Snapseed (Nik Software), $4.99

http://www.snapseed.com

http://itunes.apple.com/us/app/snapseed/id439438619

TouchRetouch HD (AdvaSoft), $0.99

http://www.iphotomania.com/application_tr

http://itunes.apple.com/us/app/touchretouch-hd/id373767768

Chapter 5: Edit Video on the iPad

Avid Studio for iPad (Avid Technology), $4.99

http://www.avid.com/US/products/Avid-Studio-app

http://itunes.apple.com/us/app/avid-studio/id491113378

iMovie for iOS (Apple), $4.99

http://www.apple.com/ipad/from-the-app-store/apps-by-apple/imovie.html

http://itunes.apple.com/us/app/imovie/id377298193

ReelDirector (Nexvio), $1.99

http://www.nexvio.com/product/ReelDirector.aspx

http://itunes.apple.com/us/app/reeldirector/id334366844

Chapter 6: Build an iPad Portfolio

Dropbox (Dropbox), Free

http://www.dropbox.com

http://itunes.apple.com/us/app/dropbox/id327630330

Portfolio for iPad (Britton Mobile Development), $14.99

http://ipadportfolioapp.com/

http://itunes.apple.com/us/app/portfolio-for-ipad/id384210950

Chapter 7: Share Photos

500px (500px), Free

http://500px.com/ipad

http://itunes.apple.com/us/app/500px/id471965292

Adobe Revel (Adobe), Free*

http://www.adobe.com/go/revel_learnmore

http://itunes.apple.com/us/app/adobe-revel/id455066445

* *$5.99 monthly subscription required after demo period.*

Flickr (Yahoo!), Free

http://mobile.yahoo.com/flickr/iphone

http://itunes.apple.com/us/app/flickr/id328407587

Flickr Studio (Keeple), $4.99

http://flickrstudioapp.com/

http://itunes.apple.com/us/app/flickr-studio/id387907682

myZenfolio (Zenfolio), Free

http://www.zenfolio.com/zf/tools/mobile.aspx

http://itunes.apple.com/us/app/myzenfolio/id359215247

Photogene for iPad (Mobile Pond), $2.99

http://www.mobile-pond.com/mobile-pond/products.html

http://itunes.apple.com/us/app/photogene-for-ipad/id363448251

Adobe Photoshop Express (Adobe), Free

http://www.photoshop.com/products/mobile/express/ios

http://itunes.apple.com/us/app/adobe-photoshop-express/id331975235

PhotoStackr for 500px (iPont), $0.99

http://ipont.ca/

http://itunes.apple.com/us/app/photostackr-for-500px/id468659684

PopBooth (Sincerely, Inc.), Free

http://popbooth.com/

http://itunes.apple.com/us/app/popbooth-photo-booth/id432092216

Sincerely Ink Cards (Sincerely, Inc.), Free

http://www.sincerely.com/ink

http://itunes.apple.com/us/app/sincerely-ink-cards-create/id477296657

SmugMug (SmugMug), Free

http://www.smugmug.com/ipad

http://itunes.apple.com/us/app/smugmug/id364894061

SmugShot (SmugMug), Free

http://www.smugmug.com/iphone/smugshot

http://itunes.apple.com/us/app/smugshot/id284129416

Snapseed (Nik Software), $4.99

http://www.snapseed.com

http://itunes.apple.com/us/app/snapseed/id439438619

Chapter 8: Helpful Apps for Photographers

500px (500px), Free

http://500px.com/ipad

http://itunes.apple.com/us/app/500px/id471965292

The Big Picture from Boston.com (Boston.com), $2.99

http://www.boston.com/tools/mobile

http://itunes.apple.com/us/app/big-picture-from-boston.com/id370709214

Easy Release (ApplicationGap), $9.99

http://www.applicationgap.com/

http://itunes.apple.com/us/app/easy-release-model-release/id360835268

Geotag Photos Pro (TappyTaps), $3.99

http://www.geotagphotos.net/

http://itunes.apple.com/us/app/geotag-photos-pro/id355503746

GoodReader for iPad (Good.iWare), $4.99

http://www.goodreader.net/goodreader.html

http://itunes.apple.com/us/app/goodreader-for-ipad/id363448914

The Guardian Eyewitness (Guardian News and Media), Free

http://www.guardian.co.uk/ipad/

http://itunes.apple.com/us/app/the-guardian-eyewitness/id363993651

HelloPhoto (Light Paint Pro), $1.99

http://www.lightpaintpro.com/?p=316

http://itunes.apple.com/us/app/hellophoto/id417608961

Intellicast HD (WSI Corporation), Free

http://www.intellicast.com/

http://itunes.apple.com/us/app/intellicast-hd/id408451987

LightTrac (Rivolu), $4.99

http://www.lighttracapp.com/

http://itunes.apple.com/us/app/lighttrac/id392892355

PhotoCalc (Adair Systems), $2.99

http://www.adairsystems.com/photocalc

http://itunes.apple.com/us/app/photocalc/id287811118

Strobox (Strobox), Free

http://strobox.com/app

http://itunes.apple.com/us/app/strobox/id339112815

Timelapse Calculator (Cateater), $0.99

http://www.cateater.com/apps

http://itunes.apple.com/us/app/timelapse-calculator/id495062782

VelaClock Sun/Moon (Vela Design Group), $3.99

http://veladg.com/

http://itunes.apple.com/us/app/velaclock-sun-moon/id418495249

Visuals by Vincent Laforet (Equity Incubator), $2.99

http://itunes.apple.com/us/app/visuals-by-vincent-laforet/id385216668

WeatherBug for iPad (WeatherBug), Free

http://weather.weatherbug.com/mobile/weatherbug-elite-apple-ipad.html

http://itunes.apple.com/us/app/weatherbug-for-ipad/id363235774

Index

Numbers

W

Walgreens app, 168
Wallee Connect system, 43–44
watermarks, 157
WeatherBug app, 174
Web sites
 Adobe Nav, 45
 companion to book, xiv, 28, 52
 dropbox.com, 141
 ipadforphotographers.com, xiv, 28
 ipadportfolioapp.com, 139
 Mpix.com, 168
 ononesoftware.com, 34
 Photoshop.com, 160, 164
 photosmithapp.com, 64
 pixelsyncapp.com, 69
 stumpstore.com, 44
 tethertools.com, 43
 Zenfolio.com, 168

white balance, 82, 94
white levels, 91
Wi-Fi networks, 151
Wi-Fi printers, 167
wired connections, 148–150
wireless connections, 151
wireless keyboards, 18
wireless memory cards, 19–21
wireless networks, 19, 22–23
wireless printers, 167–168

Y

YouTube, 125

Z

Zenfolio.com, 168